Painting Flowers
with Impact

Painting
Flowers
with Impact
in watercolour

Julie Collins

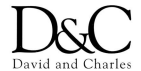
David and Charles

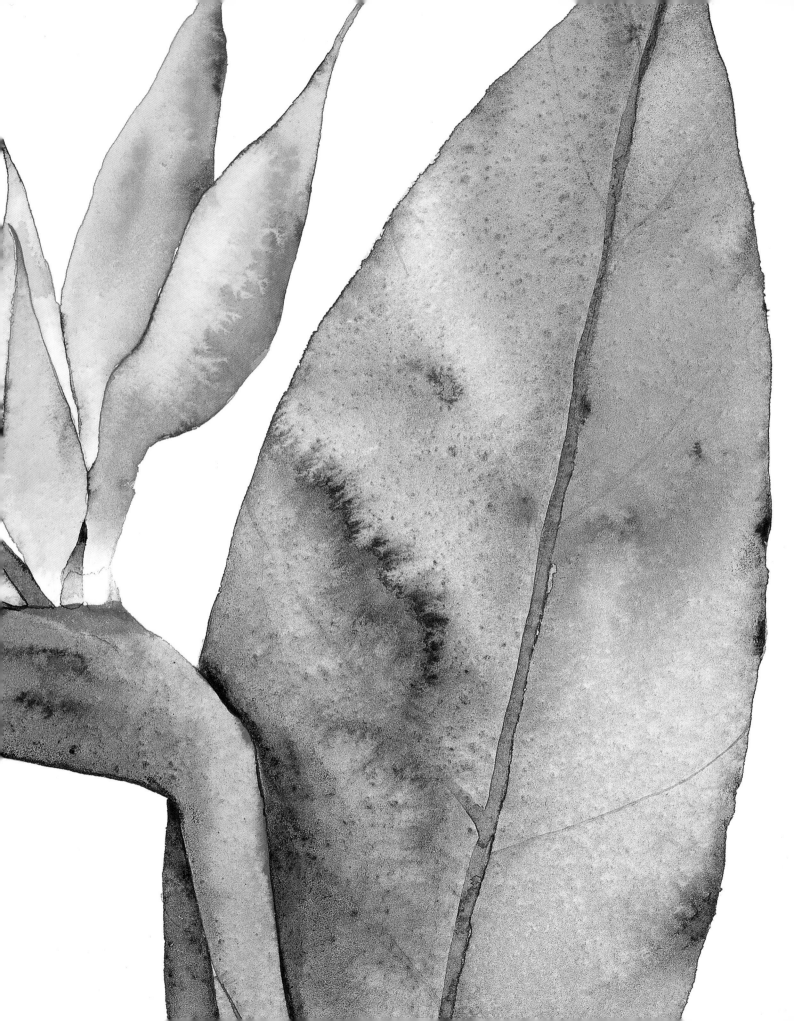

For Chris

A DAVID & CHARLES BOOK
David & Charles is a subsidiary of
F+W (UK) Ltd., an F+W Publications
Inc. company

First published in the UK in 2005
Reprinted 2006
Copyright © Julie Collins 2005

Distributed in North America
by F+W Publications, Inc.
4700 East Galbraith Road
Cincinnati, OH 45236
1-800-289-0963

A catalogue record for this book is available from
the British Library.

ISBN 0 7153 1788 1 hardback
ISBN 0 7153 1789 X paperback (USA only)

Printed in Singapore by KHL Printing Co Pte Ltd
for David & Charles
Brunel House Newton Abbot Devon

Photography George Taylor (pp 13, 14, 15, 16,
19, 21, 50–3, 58–61, 68–73, 78–85, 91–5, 104–113)

Commissioning Editor Freya Dangerfield
Desk Editor Lewis Birchon
Art Editor Sue Cleave
Project Editor Ian Kearey
Production Controller Kelly Smith

Visit our website at www.davidandcharles.co.uk

David & Charles books are available from all
good bookshops; alternatively you can contact
our Orderline on (0)1626 334555 or write to us at
FREEPOST EX2 110, David & Charles Direct,
Newton Abbot, TQ12 4ZZ (no stamp required UK
mainland).

● Contents

Introduction — 6

Materials — 10
Drawing equipment — 12
Paper — 14
Brushes — 15
Paints — 16
Other equipment — 17
Vellum — 18
The workplace — 20

Colours — 22
Basic and single colours — 24
Colours for leaves and stems — 26
Colours for autumn — 30
Mixing colours — 32
Cool and warm colours — 34
Tone, light and shade — 38

Composition — 42
Sketching and drawing — 44
Choosing size and format — 46
Making basic marks on paper — 48
Project: single flower study — 50
Project: complex flower study — 52

The Flowers — 54
Choosing what to paint — 56
Project: row of pansies — 58

Leaves and Stems — 62
Combining leaves and stems — 64
Project: hellebore — 68

White Flowers — 74
The colours of white — 77
Project: white flower on white — 78
Project: white against green — 82

Detailed Work — 86
Flower details — 88
Working on vellum — 90
Project: painting on vellum — 92
Vellum gallery — 96

An Impression of a Flower — 100
Looking for inspiration — 102
Project: exploring colour — 104
Towards abstract — 114

Gallery — 116

Failures and experiments — 122
Framing and mounting — 123

Where to see plants — 124
Bibliography — 125
Index — 127
Acknowledgements — 128

Introduction

TULIPS

12 x 30cm (4¾ x 12in)
When I planned this
composition I was
working on several
tulip pieces at once.
This is a beneficial
way to work, as it
gives you time to
think about what
each painting might
need, rather than
concentrating on
only one painting,
which can lead to
overworking it.

I love painting, and am amazed that I find
the process more and more exciting the
more I paint. Although this book is about
my flower painting during the past 30
years, I have painted every subject and
experimented with every medium available,
including painting with tea and coffee when
there was nothing else to hand!

This book is about my particular
approach to flower painting in watercolour
and the materials and methods that work for
me as an artist – I am by no means a
botanical illustrator, but I am a painter. I
want to emphasize from the outset that this
is not 'the' way to paint flowers, as I
passionately believe that everyone must
paint in the way that suits them most at any
particular time – in other words, to be
themselves and to find their own style.

For the past eight years I have mainly
concentrated on watercolour and water-based
paints. This satisfies my needs as the painter
I am now, because watercolour is
challenging, risky and fresh. You can control
it to a certain extent, but in the end it will go
it's own way and there's often a surprise in
how it dries.

As a painting student at Reading
University 23 years ago, I worked in oils and
acrylics. I enjoyed colour and working on
large-scale canvases, but often found that the
thickness of the paint limited the way I
wanted to work. I would thin the acrylics
with water and the oils with turps and then
work in glazes or thin layers. I admired
Bonnard and the amazing effects he created
with layers of paint shining through each
other, and even though he applied many

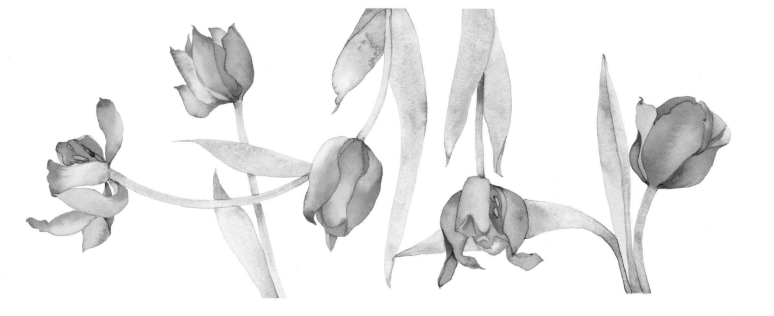

layers of paint his paintings never look overworked to me; the colour is so complicated but remains clear.

What matters in a painting?

The three most important elements in my work are colour, composition and spontaneity. In addition to Bonnard, my favourite artists include Howard Hodgkin, Terry Frost, David Hockney, Paul Klee, Helen Frankenhaler, Rory McEwen, Winifred Nicholson, Gwen John and Patrick Heron. Each of these artists is unique, and although their works are quite different in content and style, their common theme is strong colour and compositions coupled with a free style of painting.

You may wonder what any of these artists have to do with flower painting, apart from Rory McEwen, who was the finest painter of flowers in watercolour on vellum that I have ever seen. In my work I use the plant or flower as a vehicle to paint exciting and colourful compositions. This is not to say that I don't love flowers, as some of my most successful paintings are of my favourite plants, which I have responded to in an exciting way.

When I teach watercolour, one of my aims is to encourage people to paint in a freer and wetter style – to me that is what watercolour is: fresh, bright and wet. I have learnt by taking risks and failing, which is something that I still find very difficult but always pays off in the end.

Insights into the particular working habits of artists can reveal a lot about them.

While planning this book I have thought about the way I work. Being a determined person, I'm not easily put off if I want to achieve something, and can remember one occasion wanting to draw but only having a piece of paper to hand, so I improvised by using some cold tea or coffee and a stick! (I've also made the mistake of dipping my brush into my tea and drinking the paint water, but I'm sure I'm not alone there.)

Methods and discipline

Although this book is about my approach to painting watercolour flowers more freely, I do have quite a disciplined approach to work. The book runs through the order I work in, giving information about methods and materials that work for me, with particular emphasis on planning, composition and colour. Preparation is very important, as when you are well prepared it is easier to be successful when you come to work with the paint. The captions to the paintings and step-by-step projects lay out my way of working in watercolour, and show as much as possible how to achieve these effects.

The chapter 'Detailed work', covers how to paint flowers on vellum, for which I use a totally different approach to when I work on paper. Vellum lends itself to detailed and delicate watercolour painting, which I enjoy as a change from my usual freer approach.

A final note: my view is that once you have learnt all the rules off by heart and backwards, then you can start breaking them – but not before. Happy painting!

DELICATE DETAIL
18 x 8cm (8 x 3⅛in) This is painted on vellum. To achieve the detail I used tiny brushes, sizes 1 down to 000, with drybrush technique. Although this is a small painting, it took a long time to complete.

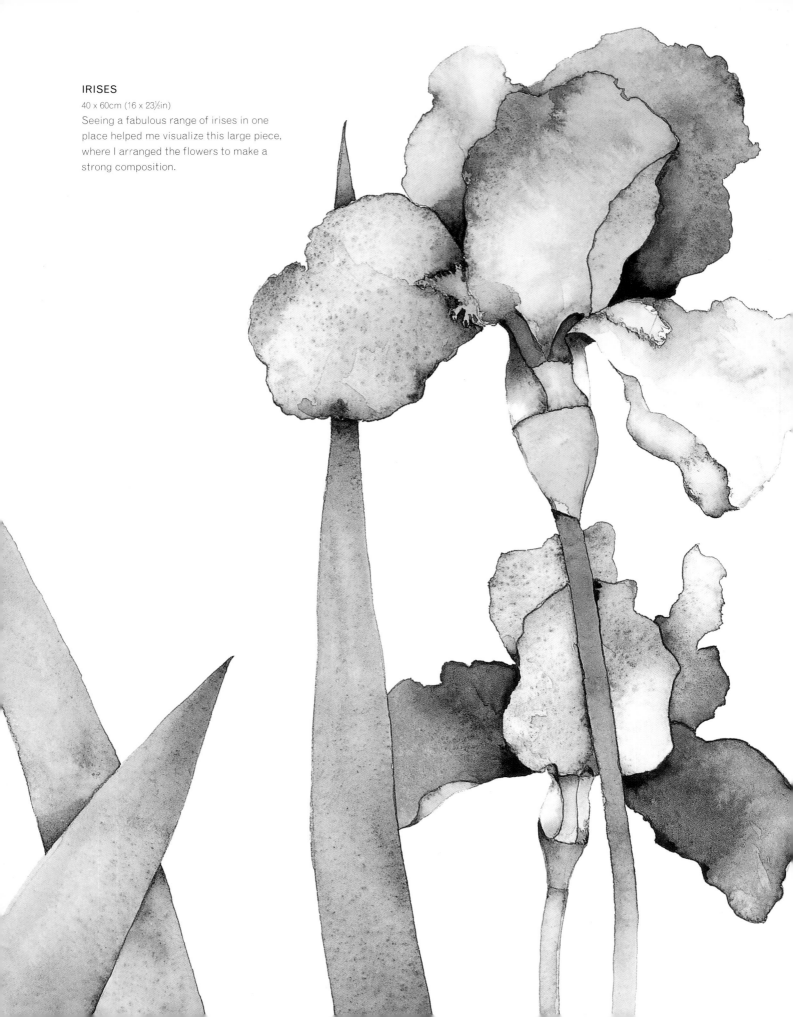

IRISES

40 x 60cm (16 x 23½in)

Seeing a fabulous range of irises in one place helped me visualize this large piece, where I arranged the flowers to make a strong composition.

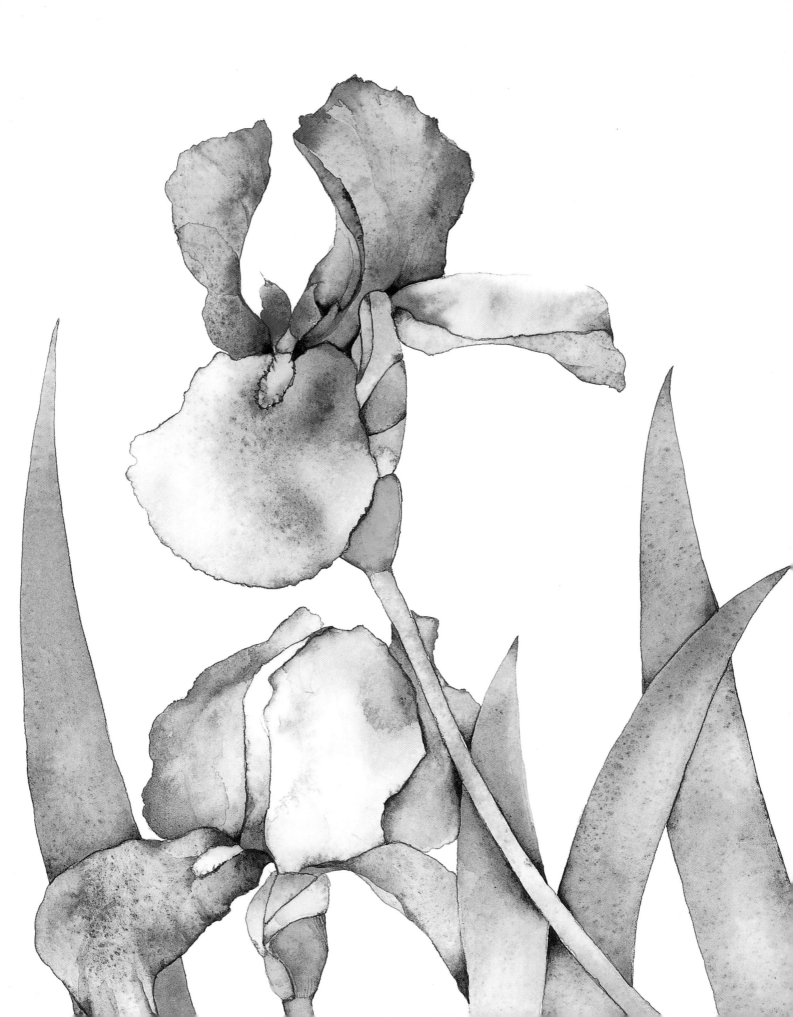

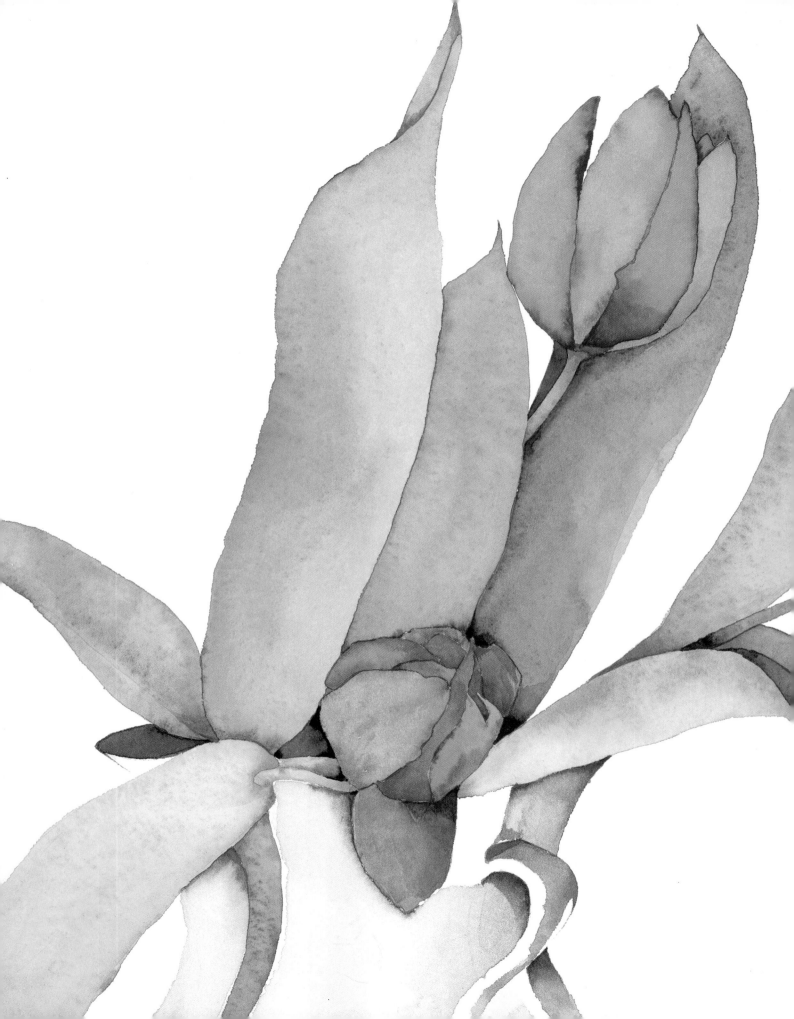

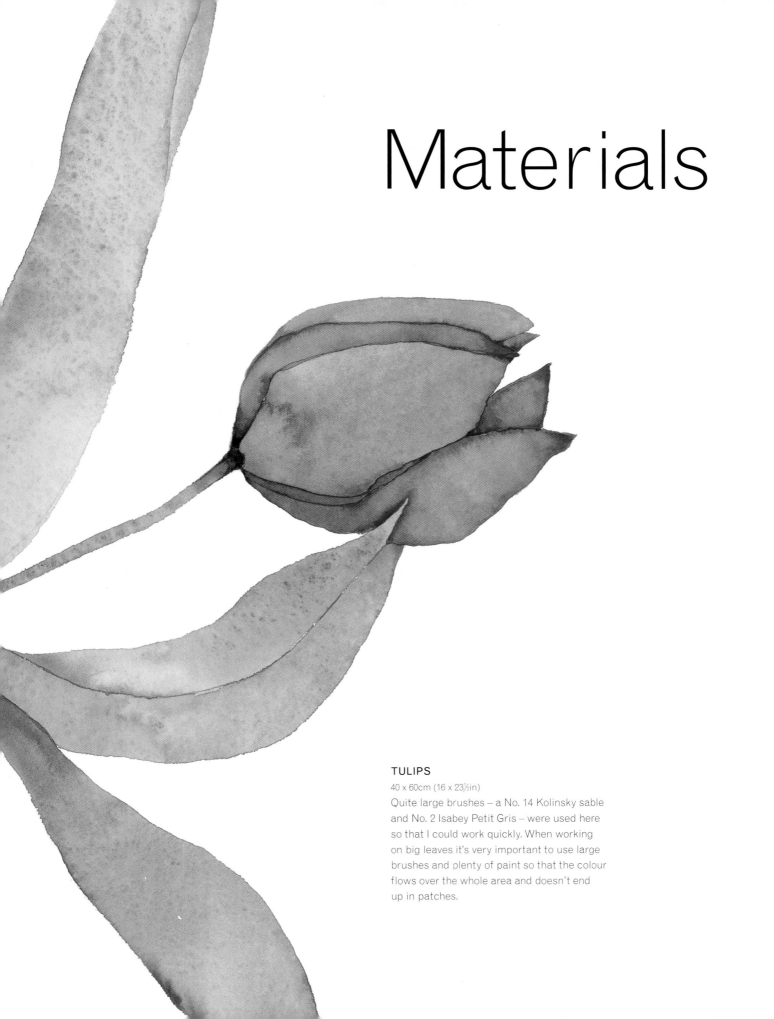

Materials

TULIPS

40 x 60cm (16 x 23½in)

Quite large brushes – a No. 14 Kolinsky sable and No. 2 Isabey Petit Gris – were used here so that I could work quickly. When working on big leaves it's very important to use large brushes and plenty of paint so that the colour flows over the whole area and doesn't end up in patches.

Drawing equipment

Although I have quite a wide range of drawing equipment, accumulated over the years, I generally only use a few things that I can't imagine ever being without.

My underdrawing for a painting is always very faint, mainly because I don't want any graphite or heavy pencil lines interfering with the painting, or dirtying any of my colours. To this end I often use either a 2H or 3H pencil or a very fine (0.35mm) retractable pencil. If you are happier working with heavier, thicker lines for your initial drawings, you can always

MY ESSENTIAL DRAWING EQUIPMENT
• Pencils (6B to 6H)
• Retractable pencils (0.35mm and 0.5mm)
• Soft, new kneaded putty eraser
• Pencil sharpener
• Ballpoint pen
• Pair of scissors
• MDF drawing boards (A4 to A0 sizes)
• Steel rulers (100cm/3ft 3in, 50cm/1ft 7in and 30cm/12in)
• Akar cutting board (90 x 60cm/3ft 6in x 2ft)
• Scalpel
• Paper
• Sketchbooks (small, Bockingford, 300gsm/140lb Rough, approx 10 x 16cm/4 x 6in; medium, Bockingford, 300gsm/140lb Rough, 16 x 20cm/6 x 8in; A4 watercolour, 300gsm/140lb NOT surface; A5 cartridge (drawing) paper)
• Inks (brown and black)
• Dip pen with fine nib
• Fine black waterproof drawing pen (0.35mm)

ADDITIONAL DRAWING EQUIPMENT
• Drawing table
• Magnifying glass
• Layout pad (A4)
• Tracing paper pad (A4)
• Larger pieces of tracing paper
• Charcoal
• Pastels

rub these out or make them more faint before you start to apply the paint.

At one time I used to draw onto tracing paper or layout pad and then trace down the image onto the paper. Using this method, you can rectify any mistakes easily and alter the position of the piece if you find this necessary. The other benefit of drawing in this way is that you can easily trace down another version. These days, however, I draw straight onto the watercolour paper and use a new, clean putty eraser to remove any mistakes very gently – I never use plastic erasers, as they can damage the paper.

I keep my pencils and equipment in a pencil case, so they can be found when needed and can be kept from accidental damage, such as being knocked off a work surface or rolling off a table.

I use a magnifying glass for working on detailed paintings, as shown in the sections about vellum (see pages 18 and 90), but there are other uses – for example, if you examine a leaf under the magnifier, it is an amazing sight that can help you see just how many colours make up that particular leaf.

The drawing mentioned in this book is generally for the purpose of painting, but I do use other materials for sketching, experimenting and particularly for other subjects like landscape. If you tend to draw with a pencil most of the time, it's worth using some charcoal, pastel or ink for a change. This can freshen up your work, and may inspire you to try different things. My favourite drawing medium is pen and ink, which is an exciting contrast to pencil drawing.

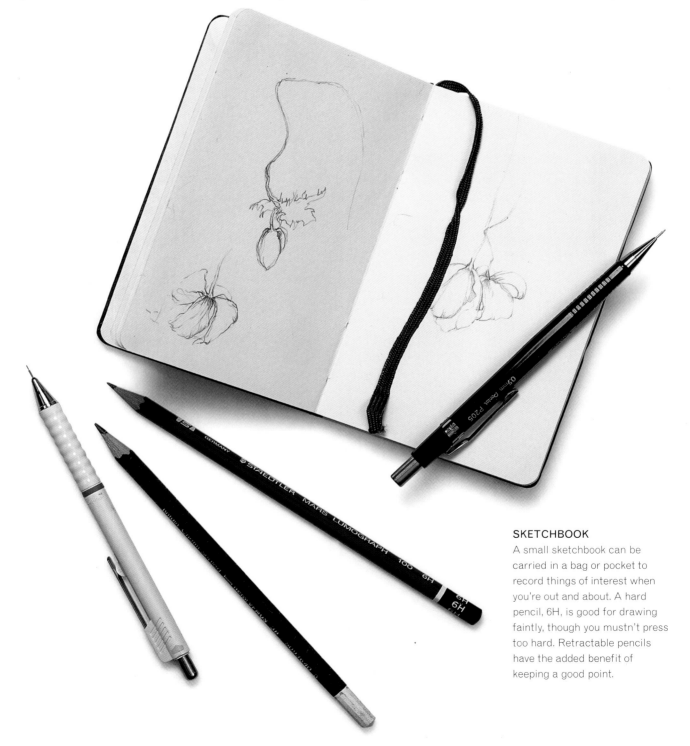

SKETCHBOOK

A small sketchbook can be carried in a bag or pocket to record things of interest when you're out and about. A hard pencil, 6H, is good for drawing faintly, though you mustn't press too hard. Retractable pencils have the added benefit of keeping a good point.

Paper

I use a wide variety of paper for my work, and my choice depends on the subject I'm painting and what I want to achieve.

Generally, for painting flowers I favour Hot-Pressed (HP) paper because of the way I can use the paint on the smooth surface. A lot of botanical artists use this paper, as they want a smooth surface to work on which suits fine detail where thin continuous lines or strokes are used; a textured surface, such as NOT or Rough, holds the paint in the grain creating a dappled or broken effect.

For me, working wet-onto-wet Hot-Pressed paper gives me the effect I want. I prefer the way the paint settles and dries evenly on this surface. In many ways it's more unpredictable, but that suits me well. I often use Saunders Waterford HP, either 300gsm (140lb) or 425gsm (200lb). Because I rarely stretch or tape down paper, I prefer to use the heavier weight, while the lighter weight is fine for smaller pieces of work – I still work very wet, but on a small study the paper doesn't cockle too much and usually dries out flat.

When I paint flowers with backgrounds I use either Bockingford NOT (Cold-Pressed) 425gsm (200lb) minimum weight, or Saunders Waterford NOT, 425gsm (200lb) minimum weight, as I particularly like the effect of the way watercolour works for backgrounds on the textured surface. On Bockingford the colours grain out excellently, especially the wetter you work.

I also like Arches Aquarelle, both HP and Rough, and can recall the first time I used this 100 per cent cotton rag: I was happily painting at my table and became aware of an unpleasant smell wafting around my studio. Was there a damp problem, or was something horrible lurking in the corner? Eventually I realized that it was the gelatine size used to prepare the paper.

All this said about my paper preferences, I would never say that you must use certain types of paper or particular manufacturers, as different papers suit everyone. Try out as many papers, surfaces and weights as you can, and see what you like best. Always choose the best within your budget to suit the effect you wish to achieve.

I buy large packs of paper and cut the sheets down myself if I need smaller pieces. I enjoy this process, especially if I'm not quite in the mood for painting, as the practical process of measuring and cutting seems to change my mind, as I start imagining what I might paint on these lovely new pieces of paper. To cut properly you need a good cutting board, a long steel rule and a sharp knife. The other option is to buy paper in pads, which immediately takes away the problem of storing and cutting – but the paper works out three times as expensive. There are mail order companies who will send you paper cut to certain sizes.

CHOOSING PAPER
Try out as many types of paper as you can to see which suits you best. Here are some that I use: Saunders Waterford HP 300gsm (140lb), Saunders Waterford HP 425gsm (200lb), Bockingford NOT 500gsm (250lb), Cotman NOT 300gsm (140lb), Arches HP 300gsm (140lb) and Schoellershammer HP 300gsm (140lb).

Brushes

It may appear as if I am very particular about the materials that I use, but it must be stressed that these are the ones that suit me. Brushes are another very personal choice, and I would recommend buying the best quality that you can afford, especially sable brushes – look after them well and they will last longer than synthetic ones.

I always use Winsor & Newton artist's watercolour paints – see page 24 for my basic palette – and sable brushes with normal-length handles (you can get ones with longer handles). Although I do use some Kolinsky sable brushes, my main ones are Winsor & Newton's 'Finest sable'. The sizes of these, from smallest to largest, are 000, 00, 0, 1, 2, 4, 6, 8, 12 and 14. For the very smallest details in vellum paintings, I have a tiny size 0000000000, which can be purchased from specialist art shops.

The only other brushes I use are Isabey Petit Gris, which are French-made squirrel mops. They are fantastic to use, as they have the most amazing point but hold a great deal of paint – so you can keep working longer without refilling your brush. (Sable works in a similar way – they hold the paint well.) The sizes of the Isabeys are 2/0, 2 and 8, but these sizes bear no resemblance to the sizes of the Winsor & Newton sables above – the Isabey 8 is very large indeed!

LOOKING AFTER YOUR BRUSHES

- Never leave brushes in water pots, as this will ruin the points.
- Use an old brush for mixing colours.
- Clean brushes carefully after use and shape them back into a neat point.
- Keep the plastic protection tubes that come with your new brushes and use them if you need to transport the brushes anywhere.
- Buy and use a brush case.

RANGE OF BRUSHES

If you have Nos. 0, 1, 2, 4, 6 and a few larger brushes, such as Petit Gris or the No. 12 shown here, you will be well equipped. The brushes depicted here are all Finest sable and Petit Gris. The No. 8 Petit Gris (second from top) is enormous but fantastic for using on very large areas.

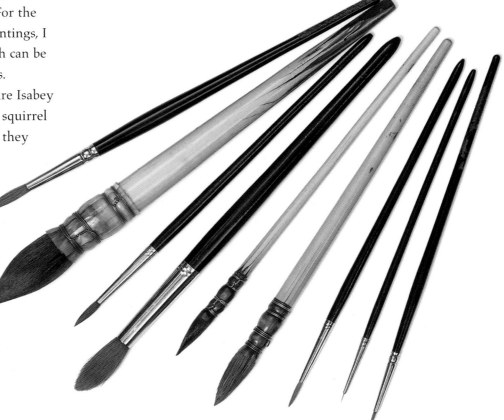

Paints

My first watercolour box had quite a limited palette. The benefit of this was that I was able to learn my way round my box, and when I felt confident with those colours I would add to them. Today, my watercolour boxes are full of Winsor & Newton Artist's watercolours, with the exception of a handful of colours from the Daler Rowney Artist's range. These are empty pans that have been filled up from tubes.

Altogether I now have five watercolour boxes, and tend to use three of them all the time. Of the other two, one is a handy small box for taking outside, where the water is included in the box, and the other is a smart wooden box that I can't bring myself to mess up, so it sits as good as new in my cupboard!

Finances permitting, I would only ever use Artist's watercolours because of the quality and range of the pigments. A tube of watercolour goes a long way, and if you can, it's always preferable to have the best, as the quality will show in your work. In addition, many colours are unavailable in Student's ranges, particularly some of the pinks, violets and reds you need to paint particular flowers.

If I was unable to buy Winsor & Newton, I would certainly paint with another range, such as Old Holland, Holbein or Schmincke. Each of these ranges includes colours that Winsor & Newton don't make, which could add interest to your palette. It's also worth noting that the same title from one manufacturer, for example, magenta, can differ from a magenta from another maker.

For painting flowers I only use 'pure' watercolour, as this produces the effects I want in this work. Watercolour behaves in a particular way that other paints don't. But in my other work I use acrylics and inks. These make a welcome change, and also create a completely different effect from watercolour on Hot-Pressed paper.

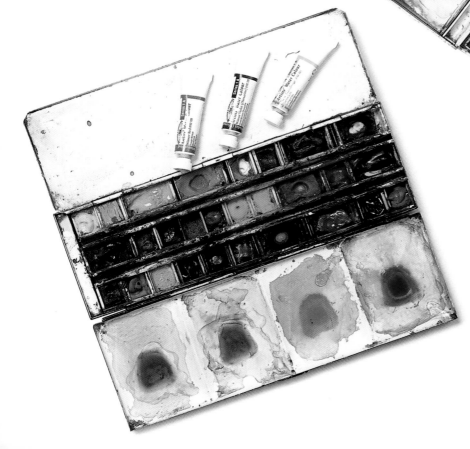

Other equipment

While thinking about the other equipment I use, I realized that I only use brushes to paint with. This may sound rather obvious, but I don't use sponges, tissues (except for cleaning up), any medium or masking fluid. I can achieve the effects I want by using my various brushes. I'm not saying that I disapprove of any of the above, it's just that they don't suit my particular needs or working methods.

Palettes

I prefer the heaviness of ceramic palettes; the plastic ones feel too flimsy. I have several ceramic palettes where I can leave mixed paint that I haven't used, as long as it's still the 'clean' colour that I mixed. Quite a few artists find plastic mixing palettes incredibly frustrating, as it doesn't seem to matter how much paint and water you put into them – there never seems to be anything there.

Accessories

I keep my brushes, pencils and rulers in a variety of pots and jam jars; I have 'special' pots for my best brushes – a ceramic Dundee marmalade jar and ceramic pot from Granada.

I have a plastic pipette to put water into my palette – a labour-saving device. I use mountains of tissue paper to clean up my palettes, brushes and table. I don't know what I'd do without masking tape – it's worth having at least five different widths. Blu-tack comes in very handy for fixing small and medium paintings to the wall so that you can see them more easily. I have a variety of old mounts that I use to help decide on the format and composition of my paintings. Hold them over your drawing to try different crops or frame the composition.

A lamp with a daylight bulb is absolutely essential. It enables you to work when the light is poor, and certainly helps keep the colours more true than a normal bulb, which casts a yellow shade.

Always carry a notebook to jot down an idea that may spring to mind, as you can guarantee if you don't write it down you won't remember what it was – only that you'd had an idea! Years ago I bought a handmade painting case from a man on a painting course. I don't use it all that often now, but it's great for taking to work outside, as all the equipment is well protected and I can lean on the case to draw and paint.

In addition to a plan chest, I use different-sized portfolios for carrying work around – they're also good for storage.

Boards

For boards, I buy offcuts of MDF at DIY stores and get them cut into various sizes. This is much more economical than buying ready-made boards, and it means you always have plenty of boards in different sizes so that you won't be using an enormous board for a small painting or, worse still, a board that is too small for the job.

ESSENTIAL ODDMENTS

- Notebook
- Tissue paper
- Pipette
- Masking tape
- Blu-tack
- Old mounts
- Wooden art case with sections to hold paper, paints, drawing equipment
- Lamp with daylight bulb
- Various portfolios

Vellum

Vellum is treated leather or similar animal skin that is used for calligraphy, painting and illuminated work. There is a great tradition in work on vellum, and the material has been used for centuries for important documents such as the beautiful illuminated mediaeval manuscripts seen at the British Museum, London, or the Fitzwilliam Museum, Cambridge. The botanical illustrator Ehret (1708–70) painted on vellum, and examples of his finest pieces can be seen in the Print Room at the Victoria & Albert Museum, London, and at the Royal Horticultural Society at Kew Gardens near London.

Any work on vellum will be preserved much longer than on paper; in fact, the Houses of Parliament stopped using it for important documentation only very recently, probably because of the prohibitive cost of the material. A small piece of manuscript vellum approximately 15 x 10cm (6 x 4in) will cost about £5. Larger pieces are not pro rata in price, as it is more difficult to get a big piece with the same quality of surface all over, so a piece about 48.5 x 63.5cm (19 x 25in) could cost about £100 – and the prices of vellum do tend to fluctuate.

HELLEBORUS FOETIDUS

9 x 6cm (3½ x 2⅜in)
This was painted on medium-weight manuscript vellum. As rubbing out would harm the prepared surface, the image was drawn on tracing paper and traced onto the vellum.

TYPES OF VELLUM

- **Manuscript:** Medium-weight calfskin manuscript vellum is the most suitable for botanical painting in watercolour.
- **Kelmscott:** Kelmscott is much thicker, and is prepared with a chalk-based coating. This is ready to use without further preparation, and is ideal for miniatures as the finished surface bears a similarity to porcelain.
- **Goat:** This is usually medium-weight, but is more speckled in appearance than calfskin.
- **Sheepskin:** Sheepskin can be thinner and is therefore not particularly suitable for painting.
- **Parchment:** This is much thinner, and is definitely not suitable for painting.

The workplace

The studio

Being comfortable in the place where they work is incredibly important to all artists. When I moved studios a couple of years ago, I gained a much larger and more versatile space with old wooden floorboards. The new studio was full of character, with an interesting view and good enough light – but I didn't feel comfortable.

Although my previous studio was far too cramped and it was time to move on, it also had a very private outlook. The new space had large floor-to-ceiling windows overlooking other buildings. For some time I felt very uncomfortable, as if I was in a goldfish bowl, and thought that everyone was looking at me! With time and some good blinds, however, I now feel great in my space; it feels like home and a very inspiring place to work.

Feeling comfortable or 'just right' while you work is very important. Particularly when working on large pieces, I paint on the floor so that I can move around freely to whatever part of the painting I'm developing. This harks back to my childhood, as I remember feeling most comfortable drawing on the floor. And thinking about it, although I have a table to work at for smaller pieces, very often I stand up as I paint.

Some students tell me that they haven't done any painting since they last saw me, partly because they haven't got anywhere to leave their work out. This is a common

problem, as if you have little time to paint, then setting up and clearing away can take up your entire allocation. If you are able to make a space somewhere in your home for your art work, do. Other students have been inspired after a painting course, and have returned home ready to make some big changes. There are also stories of people converting garages, taking over a rarely used spare bedroom, or just rearranging a room so that it can be used for two purposes. All of these actions result in people doing more of their art work, which is great.

Working outside

Literally working outside is not always easy, and if you're a flower painter you rarely need to work outdoors, as your subject can usually be cut or transported in a pot to a comfortable place inside.

Sometimes, though, it's a good idea to work elsewhere, and you can feel very inspired when you take yourself out of the studio. On one occasion I spent a very hot day in the orchid house at the RHS gardens at Wisley, Surrey, where at first I felt incredibly conspicuous standing there with my pencil and paper. Once I got into the swing of it, I enjoyed the experience of working in a different place and drawing directly from such unusual plants. Even the people who asked me about what I was doing didn't put me off, and I came home with some fresh drawings and notes about

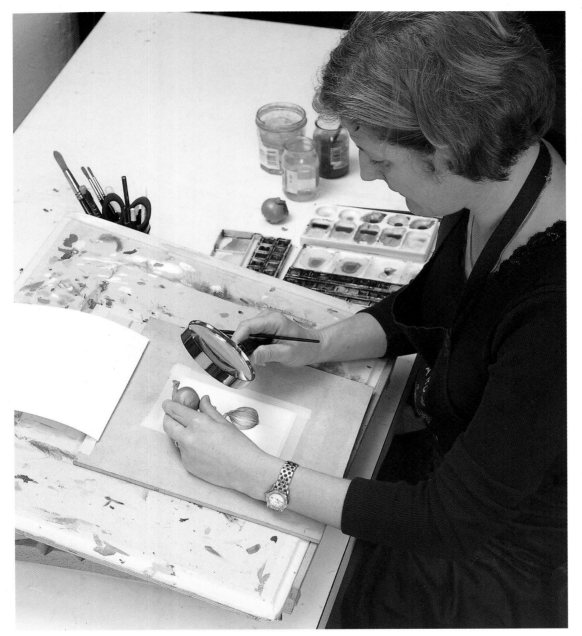

A CLOSER LOOK
This shows me at work in my studio, studying the onion for the vellum project on page 92.

what I'd seen. It's easy to forget that you can get stale by staying in the studio too much.

Similarly, when I have been abroad, I have sat in the shade and painted the magnificent calla lilies, hibiscus and wonderful palms. Usually this has resulted in a new approach to my work inspired by the subject, my limited travelling palette and small watercolour pad – or simply by being away from the norm.

Painting courses

It's very satisfying when a student comes to one of my courses and goes away saying that they're full of new ideas and feel inspired. If you're feeling stale and stuck in a rut, it can be a good idea to **attend** a course that appeals to you as this could spark off some new ideas. A change of scene and new approaches can be refreshing.

Colours

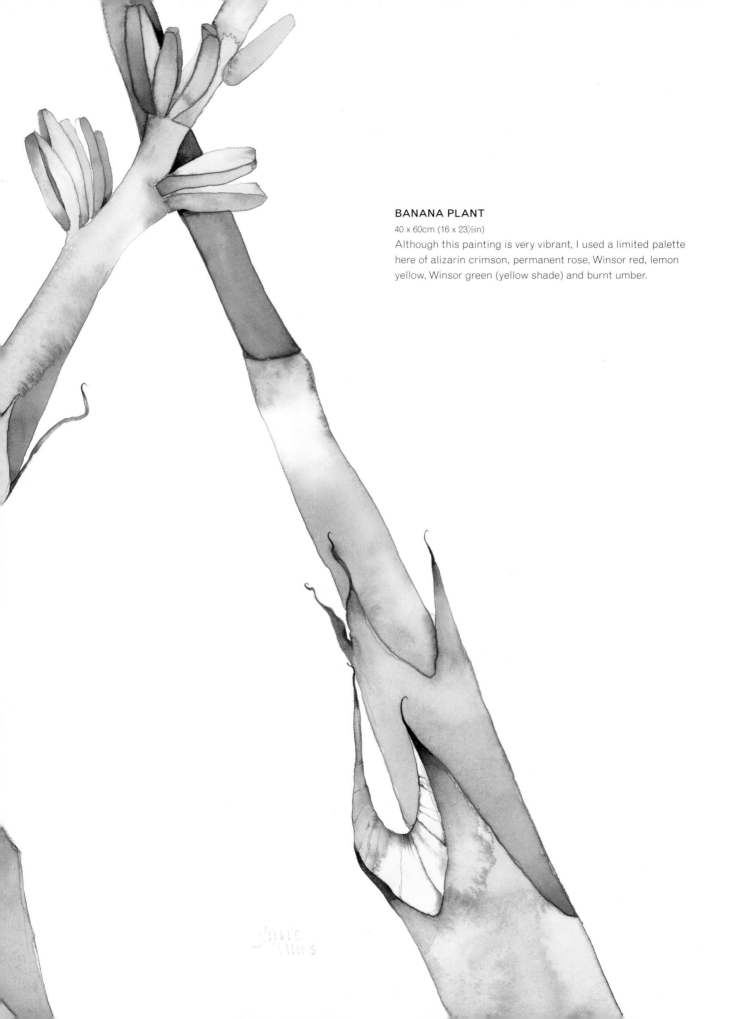

BANANA PLANT

40 x 60cm (16 x 23½in)

Although this painting is very vibrant, I used a limited palette here of alizarin crimson, permanent rose, Winsor red, lemon yellow, Winsor green (yellow shade) and burnt umber.

Basic and single colours

I love colour in all areas of my life, from clothes to the garden and into the house. When I'm choosing a pink it has to be the right pink – any old pink won't do, as it has to 'go'.

Painting is great for colour lovers, as they can spend at least half their time considering colour. Sometimes, however, this can be quite overwhelming, and instead of practising what you preach and using a limited palette, you can get carried away by using too many colours in a painting.

With the basic palette listed here you can mix most colours that you need for flower painting. If you get to know your basic palette inside out – what to mix with what to get the colour you want, and how all the colours work together – then you can introduce some newcomers. If you start with too many colours, the box becomes overwhelming.

A worse situation is when you haven't got the colour you need in your box. When I bought my first watercolour box I decided to paint some pink flowers and became incredibly frustrated as I used scarlet lake, which would not turn pink! There were two problems: the first was that the box I had bought was set up as a landscape box, as are most watercolour boxes. There are certain pinks, among other colours, that you need for flower painting and they aren't included in landscape boxes. The second problem was that I was used to painting in oils and acrylics, where you just added white to a red to get a pink… It was time to start learning to think differently.

After this experience I decided to set up my own watercolour box, which means that now all the colours in the box are employed. One of the disadvantages of ready-filled boxes is that there will always be colours in there that you won't or shouldn't use. If you have the 'wrong' blue for the job in your box, it is all too tempting to use it and think it will 'do' anyway. As mentioned on page 16, if you squeeze your colours from tubes into an empty palette, there will be no superfluous colours, only those that you need.

USING PINKS

28 x 16cm (11 x 6¼in) The pinks used for these sweet peas were mixed from permanent rose, permanent alizarin crimson, ultra-marine and Winsor violet. A subtle amount of one red mixed with another can produce a wide variety of pinks.

BASIC PALETTE FOR FLOWER PAINTING

- Permanent rose
- Permanent alizarin crimson
- Winsor red
- Cadmium or Winsor orange
- Lemon or Winsor yellow
- New gamboge yellow or cadmium yellow
- Yellow ochre or raw sienna
- Burnt sienna
- Indian red
- Ultramarine
- Cobalt blue
- Winsor violet
- Hooker's green or Winsor green (yellow shade)

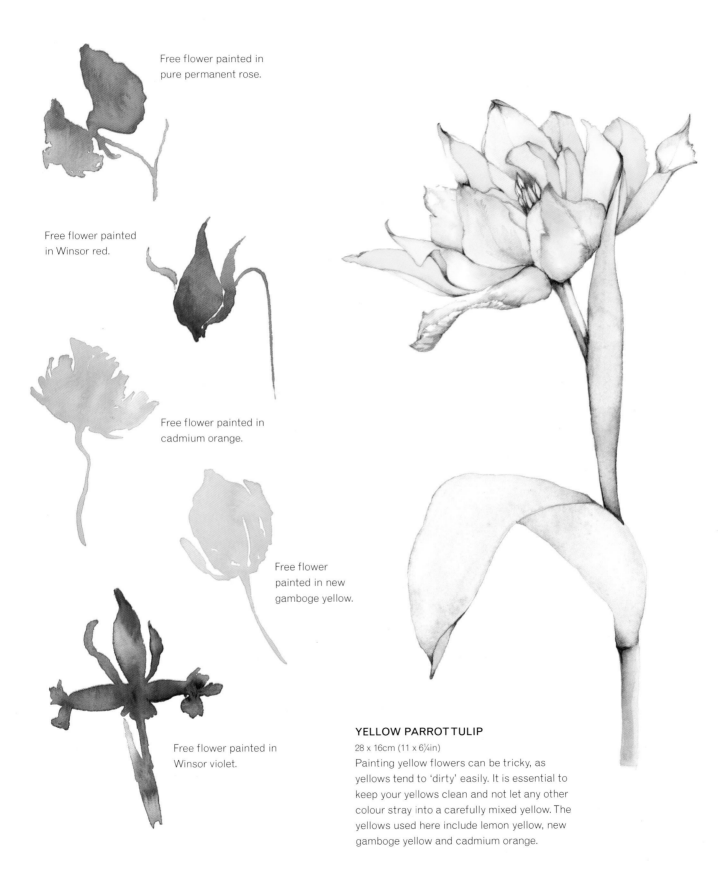

Free flower painted in pure permanent rose.

Free flower painted in Winsor red.

Free flower painted in cadmium orange.

Free flower painted in new gamboge yellow.

Free flower painted in Winsor violet.

YELLOW PARROT TULIP
28 x 16cm (11 x 6¼in)
Painting yellow flowers can be tricky, as yellows tend to 'dirty' easily. It is essential to keep your yellows clean and not let any other colour stray into a carefully mixed yellow. The yellows used here include lemon yellow, new gamboge yellow and cadmium orange.

Colours for leaves and stems

Many people have terrible trouble with both leaves and stems. They don't like them as much as the flowers, and some don't particularly like green, either – not a very good start for flower painting!

I used to avoid painting leaves and stems whenever I could, but when I painted arum lilies I suddenly felt inspired by green and saw that the leaves and stems could be just as exciting as the flowers. This may sound quite

PALETTE FOR MIXING GREENS

- Lemon yellow or Winsor lemon
- New gamboge yellow or cadmium yellow
- Yellow ochre or raw sienna
- Burnt sienna
- Ultramarine
- Cobalt blue
- Prussian blue
- Winsor blue (red and green shades)
- Permanent sap green

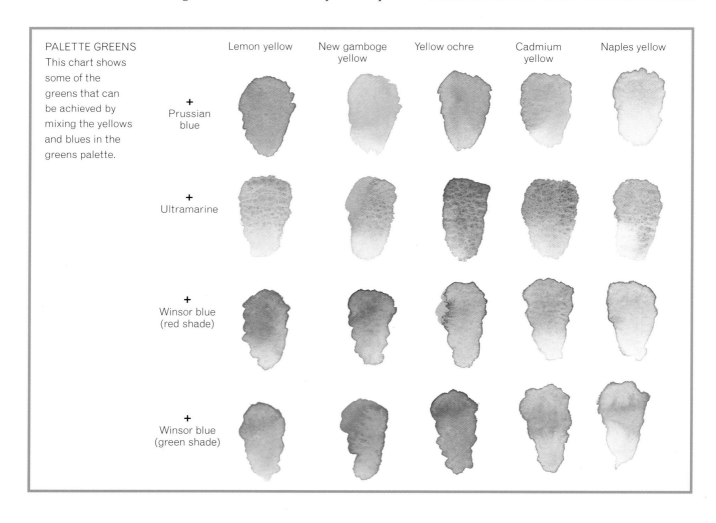

PALETTE GREENS
This chart shows some of the greens that can be achieved by mixing the yellows and blues in the greens palette.

	Lemon yellow	New gamboge yellow	Yellow ochre	Cadmium yellow	Naples yellow
+ Prussian blue					
+ Ultramarine					
+ Winsor blue (red shade)					
+ Winsor blue (green shade)					

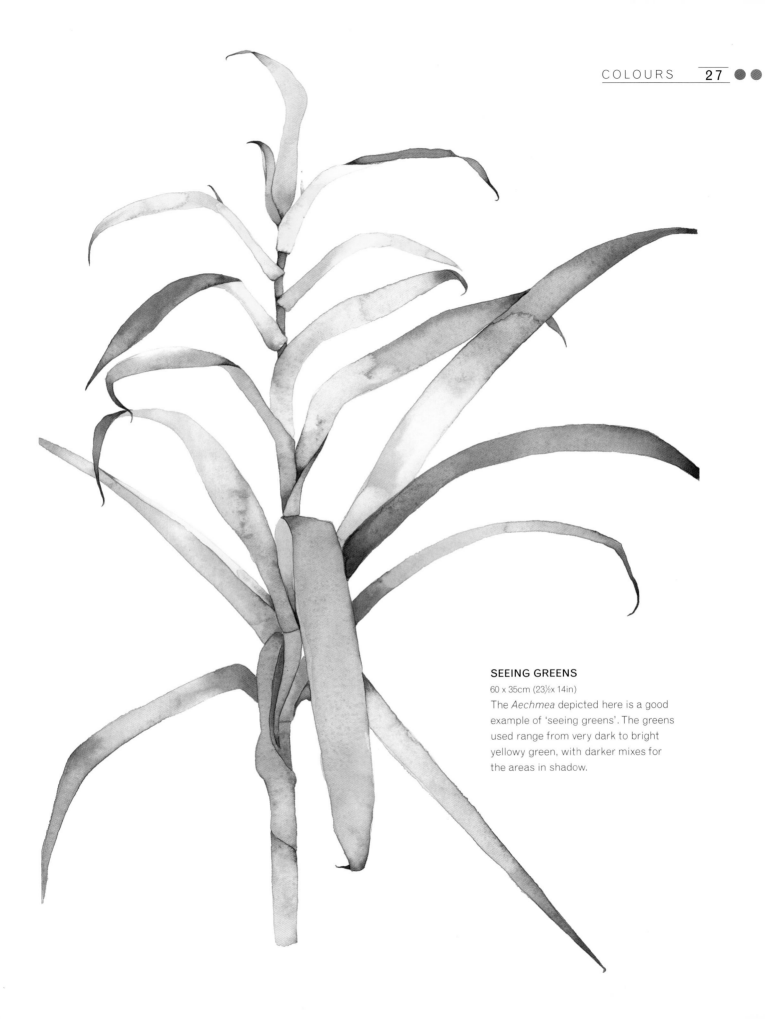

SEEING GREENS
60 x 35cm (23½ x 14in)
The *Aechmea* depicted here is a good
example of 'seeing greens'. The greens
used range from very dark to bright
yellowy green, with darker mixes for
the areas in shadow.

dramatic, but it was almost a revelation, as I hadn't really 'seen' greens before.

Too often the leaves and stems let down a beautiful flower painting. During one class I taught we painted the leaves and stems first and saved the flowers until last. This worked amazingly well, and the leaves and stems were much stronger than usual. When I teach I encourage people to be as enthusiastic about their greens as the flowers; again, it's about really seeing the colours in the leaves and stems. One brilliant aspect about this is the interchange of colour that you often get in flowers and stems – this is where you see some of the pink from the flower in the stem or leaf, and vice versa.

One of the troubles with greens is that it's all too easy to rely on a green straight from the palette, with little thought as to whether it's the right green, whether it's bright enough, yellow enough and so on.

A couple of years ago I ran a course on greens. We spent most of the first day mixing various greens and making charts of some of the resulting colours. This is a very good way to learn about colour. At the end of the day you will have all your charts and can refer to them when you are unsure which green you need for your painting, or how to achieve it. The chart on page 26 shows greens mixed from the basic leaf palette. The greens in the chart below resulted from a more relaxed and inspiring aproach involving an element of experimentation.

RANDOM MIXES
This chart was made by randomly mixing the blues and yellows in my palette. My intention with this exercise was to create named greens, such as cool green, apple green, lime green, dull green, bright green, dark green, pale green, blue green, eau de nil, grey green, yellow green, shadow green and so on. Keep notes of the colours and dilutions, so that you can make the greens again.

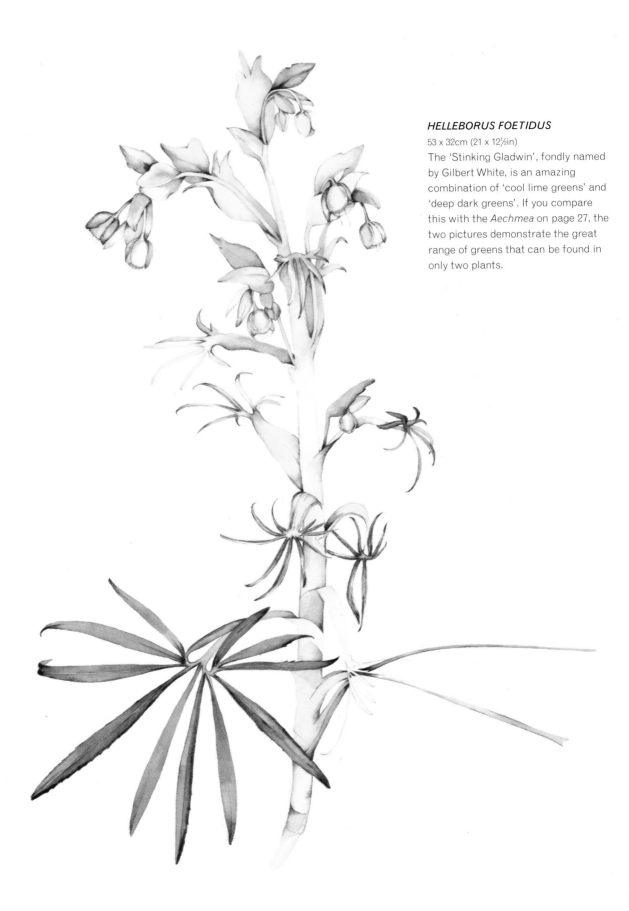

HELLEBORUS FOETIDUS
53 x 32cm (21 x 12½in)
The 'Stinking Gladwin', fondly named
by Gilbert White, is an amazing
combination of 'cool lime greens' and
'deep dark greens'. If you compare
this with the *Aechmea* on page 27, the
two pictures demonstrate the great
range of greens that can be found in
only two plants.

Colours for autumn

The wonderful, rich colours of autumn and winter foliage require a particular palette, listed below, although most of the colours will be also be included in your basic flower and leaf palettes.

The autumn/winter palette can be an extremely inspiring one that always seems to respond well to painting decaying subject matter, such as leaves with holes in them, gnarled twigs, and also bulbs. The colours can be used pure or mixed, as in the chart below, to create a subtle range of soft golds, oranges, browns and yellows that blend well with hints of green.

One autumn I spent days on end hiking around the RHS gardens at Wisley in Surrey, collecting autumn leaves to press and then paint. I'd go home with carrier-bag loads of exciting material. Try to get outside for a welcome change from the studio to look for new subject matter.

AUTUMN/WINTER PALETTE
• Lemon yellow or Winsor lemon
• New gamboge yellow or cadmium yellow
• Yellow ochre or raw sienna
• Burnt sienna
• Burnt umber
• Raw umber
• Indian red
• Light red
• Permanent alizarin crimson
• Winsor red or cadmium red
• Cadmium orange
• Ultramarine
• Hooker's green or viridian
• Winsor violet

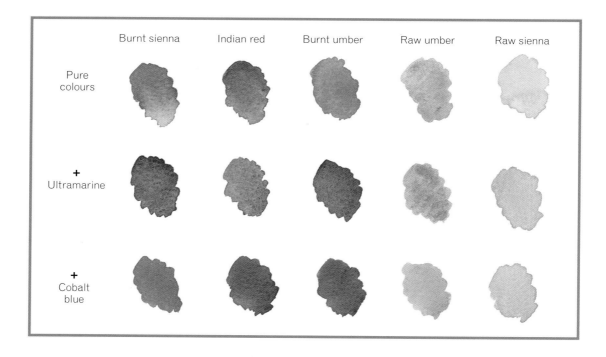

	Burnt sienna	Indian red	Burnt umber	Raw umber	Raw sienna
Pure colours					
+ Ultramarine					
+ Cobalt blue					

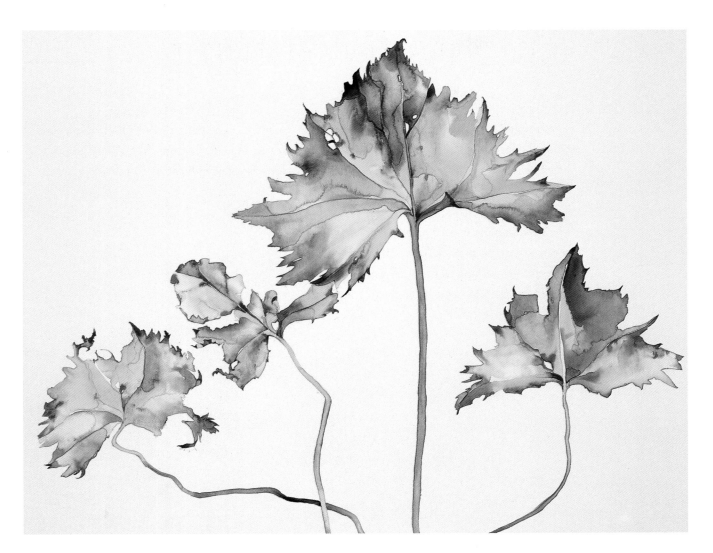

AUTUMN LEAVES
Above: 51 x 76cm (20 x 30in)
Left: 22 x 15cm (8½ x 6in)
Colourful autumn leaves are fantastic to paint. You can 'go to town' with your autumn palette (opposite), using some colours straight from the palette and others subtly mixed, such as permanent alizarin crimson with a touch of burnt sienna.

Mixing colours

Experiment with mixing colours and seeing how different a colour will look when you add a touch of another colour to it. By experimenting you can learn a lot. Before you start to mix your colours, make a chart of the colours in your box, as below, arranged in the same order as your box, so that you get to know them. Pure pigment looks very different in the palette from when wet on the paper.

Some mixes to experiment with might be:
1 Lemon yellow with new gamboge yellow (pale mix and mid-tone mix).
2 New gamboge yellow with a touch of lemon yellow (pale mix and mid-tone mix).
3 New gamboge yellow with a touch of cadmium orange – one mid-tone mix.

From three colours you will have created five new colours, none of which are straight from the tube.

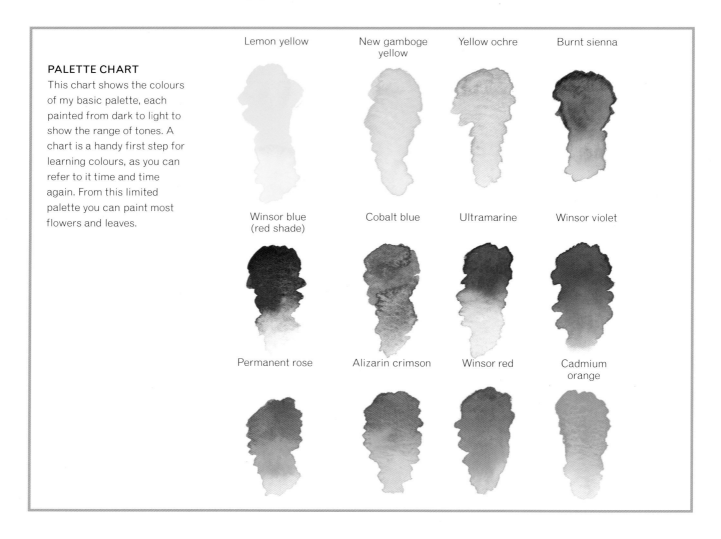

PALETTE CHART
This chart shows the colours of my basic palette, each painted from dark to light to show the range of tones. A chart is a handy first step for learning colours, as you can refer to it time and time again. From this limited palette you can paint most flowers and leaves.

Lemon yellow

New gamboge yellow

Yellow ochre

Burnt sienna

Winsor blue (red shade)

Cobalt blue

Ultramarine

Winsor violet

Permanent rose

Alizarin crimson

Winsor red

Cadmium orange

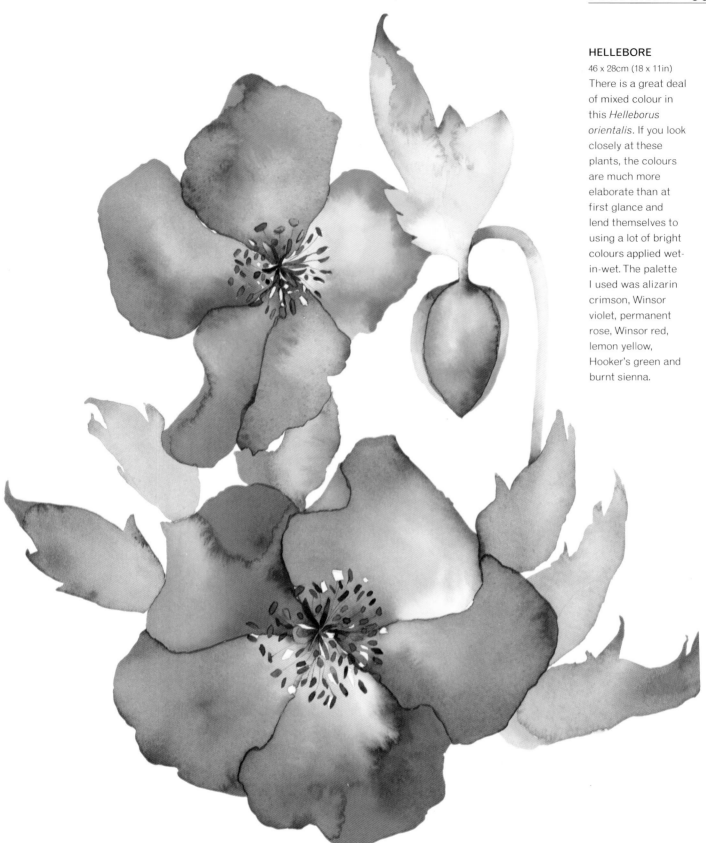

HELLEBORE

46 x 28cm (18 x 11in)
There is a great deal
of mixed colour in
this *Helleborus
orientalis*. If you look
closely at these
plants, the colours
are much more
elaborate than at
first glance and
lend themselves to
using a lot of bright
colours applied wet-
in-wet. The palette
I used was alizarin
crimson, Winsor
violet, permanent
rose, Winsor red,
lemon yellow,
Hooker's green and
burnt sienna.

Cool and warm colours

Painting flowers and plants is ideal for including an effective combination of cool and warm colours in your work. So many warm flowers have a contrast of cool colours in their leaves – for example, the contrast of the hot reds in a poppy with the cool grey-blue greens of its leaves, makes a perfect complementary colour combination and an inspiring subject.

If this is not obvious in the plant you intend to paint, look for the contrasting cool and warm colours. Whenever you paint a largely 'green' piece, say, make sure to include the warm yellow greens and the cooler blue greens.

I am passionate about how particular colours work together, and have found that if you think of them as hot, warm or cool, this helps with painting – a successful 'palette' is one of the key elements to effective paintings. Warm colours tend to stand out, whereas cooler ones recede, which helps to create movement or space in a picture.

PARROT TULIP: WARM

40 x 50cm (16 x 19½in) This is a good example of a warm/hot palette – compare this treatment with that opposite.

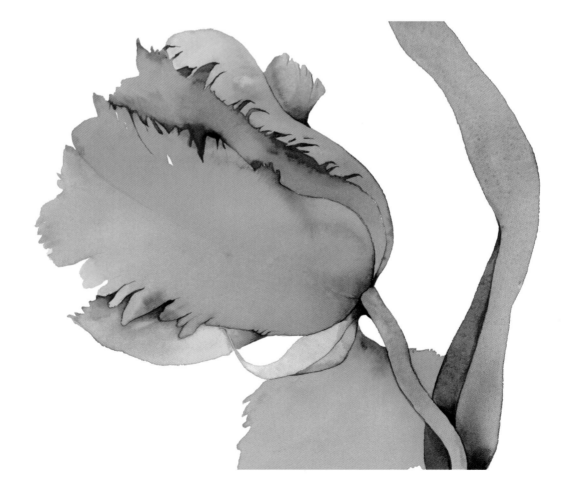

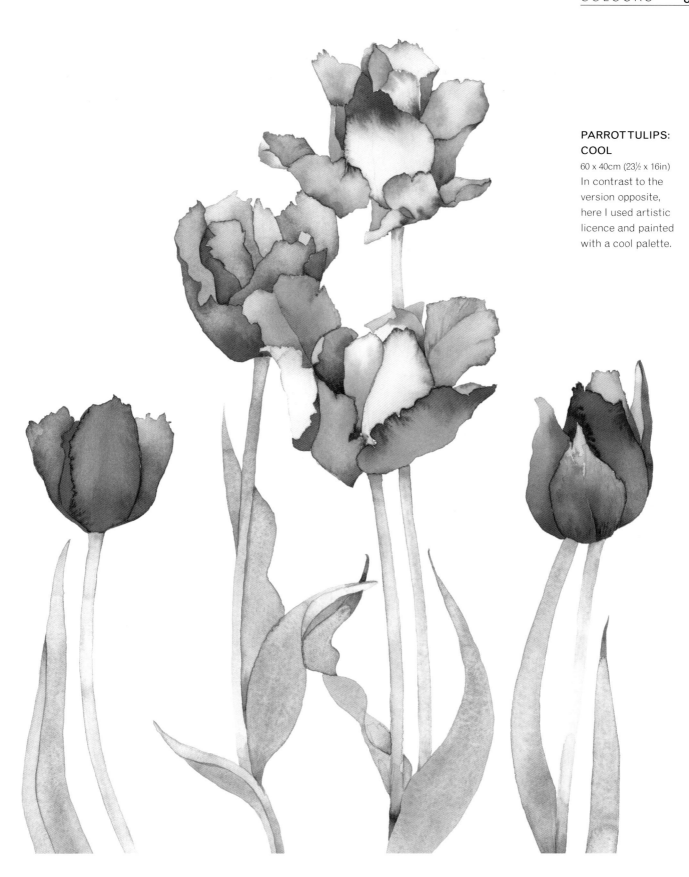

PARROT TULIPS: COOL
60 x 40cm (23½ x 16in)
In contrast to the version opposite, here I used artistic licence and painted with a cool palette.

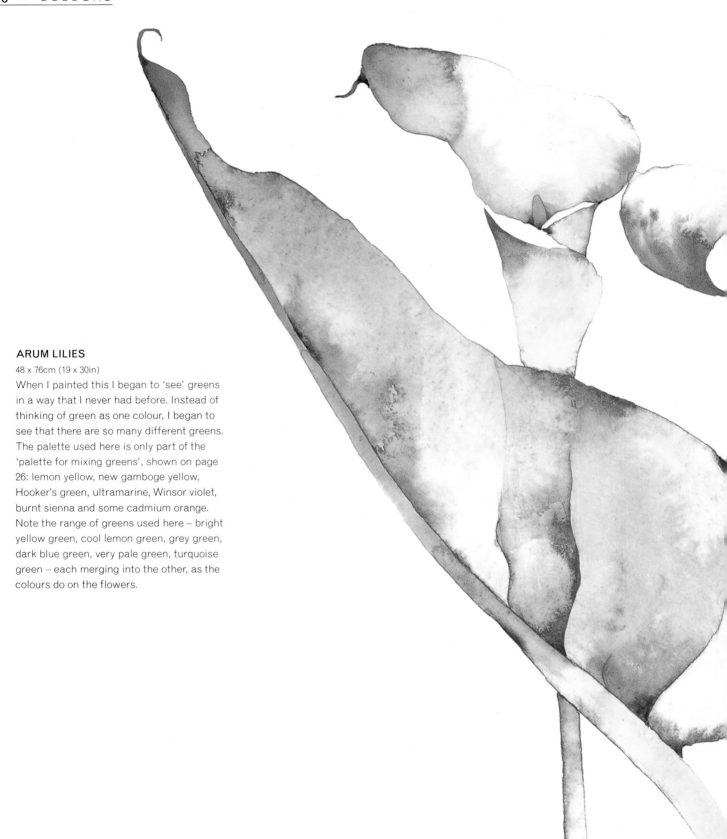

ARUM LILIES

48 x 76cm (19 x 30in)

When I painted this I began to 'see' greens in a way that I never had before. Instead of thinking of green as one colour, I began to see that there are so many different greens. The palette used here is only part of the 'palette for mixing greens', shown on page 26: lemon yellow, new gamboge yellow, Hooker's green, ultramarine, Winsor violet, burnt sienna and some cadmium orange. Note the range of greens used here – bright yellow green, cool lemon green, grey green, dark blue green, very pale green, turquoise green – each merging into the other, as the colours do on the flowers.

Tone, light and shade

I will never forget painting a life-size cabbage. It was the first large watercolour I'd tackled. When I thought I'd finished it, the result appeared to be a bit flat, and on closer inspection it had a limited tonal range where there weren't enough darks included on some of the leaves. Adding some shadows here and there made the painting come alive, but still I felt dissatisfied and decided to add a very dark blue background – the idea was that the drama of the dark blue would set off the middle tones of the cabbage. Full of fear and trepidation, I mixed palette-loads of dark blue and tested it before I began.

When I'd applied the last brushful I breathed a massive sigh of relief and put the painting on the floor to dry. Feeling very pleased with myself, I sat back; within seconds my son came crawling into the studio as fast as he could, and – you've guessed – crawled over the wet blue background. Fortunately, he only left a small fingerprint (which added character to the piece), but painting that cabbage was a turning point, where I really learnt about the importance of tone and light and shade.

The tonal range in your painting also creates interest in your work. If your tones are all too similar, this has the effect of making your painting look dull. Contrast in tone tells you that one petal is in front of the other, whereas if the two petals are the same tone, they may merge together and appear as if they are one.

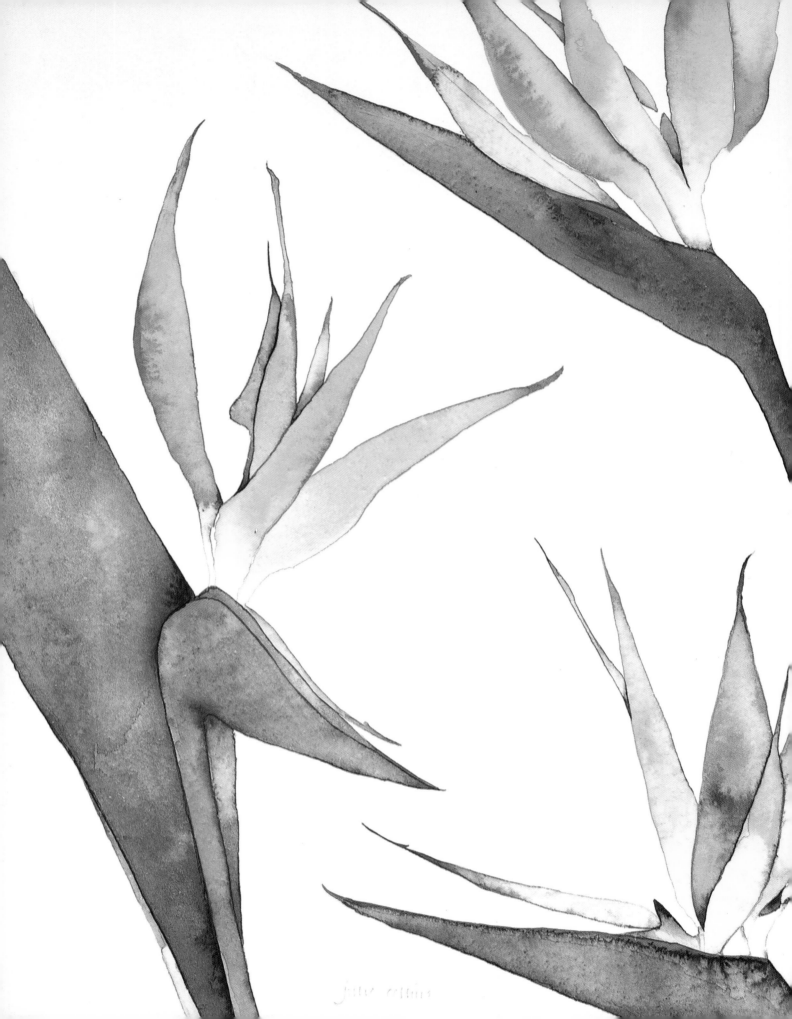

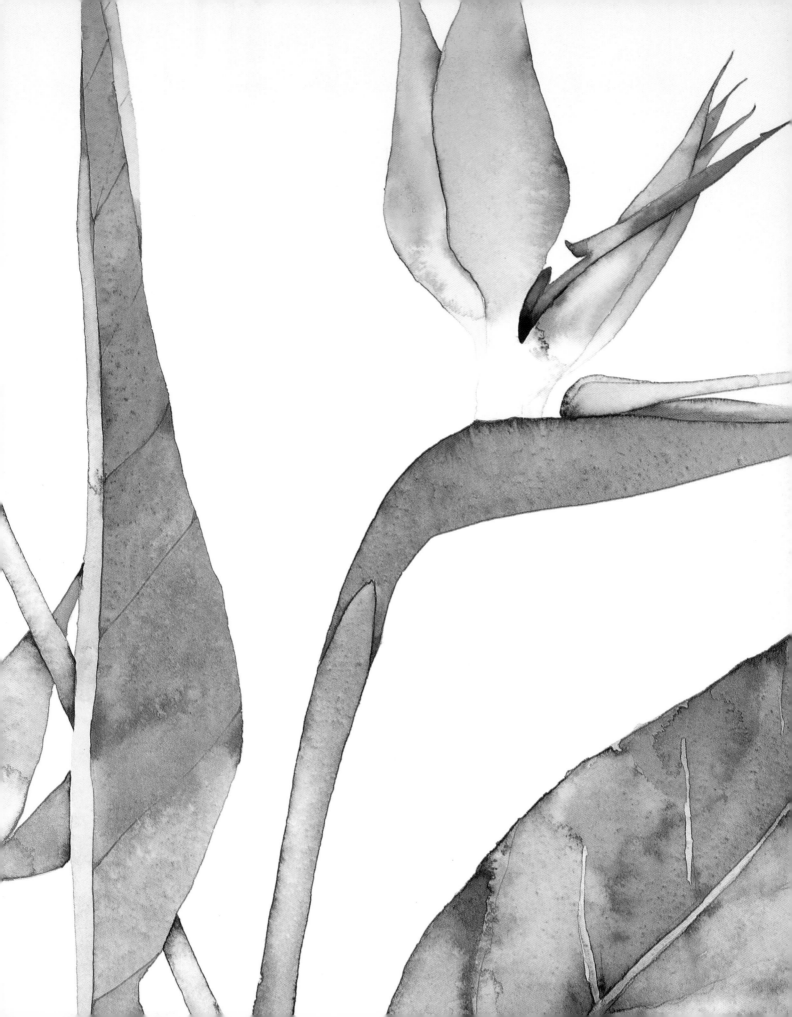

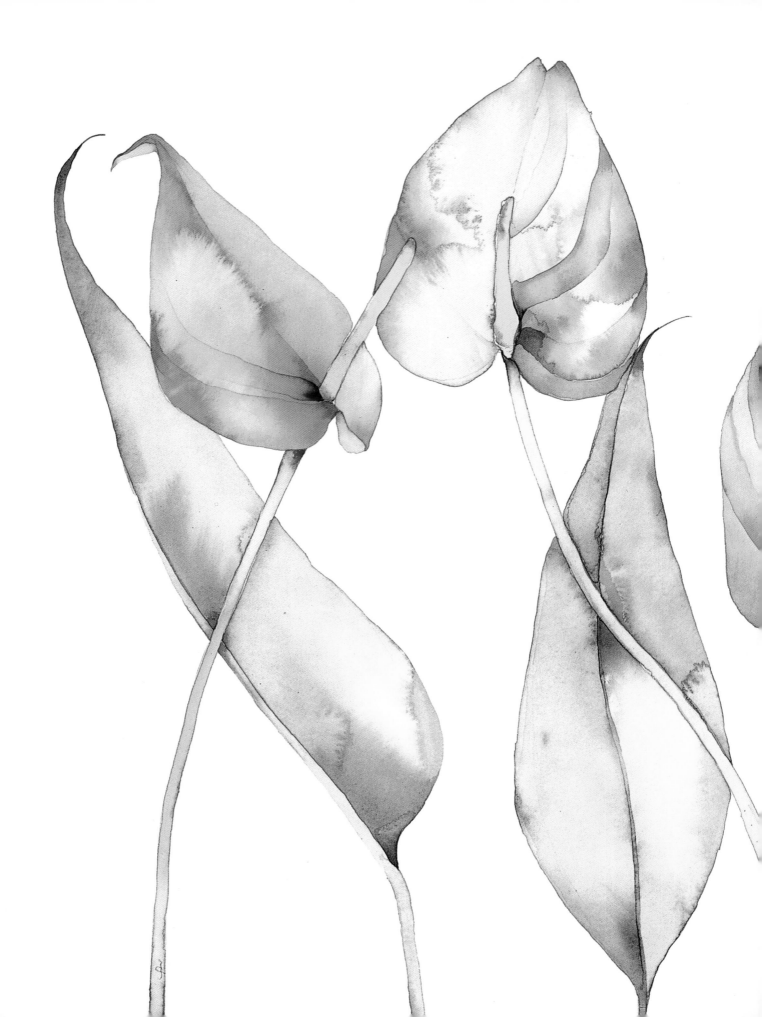

Composition

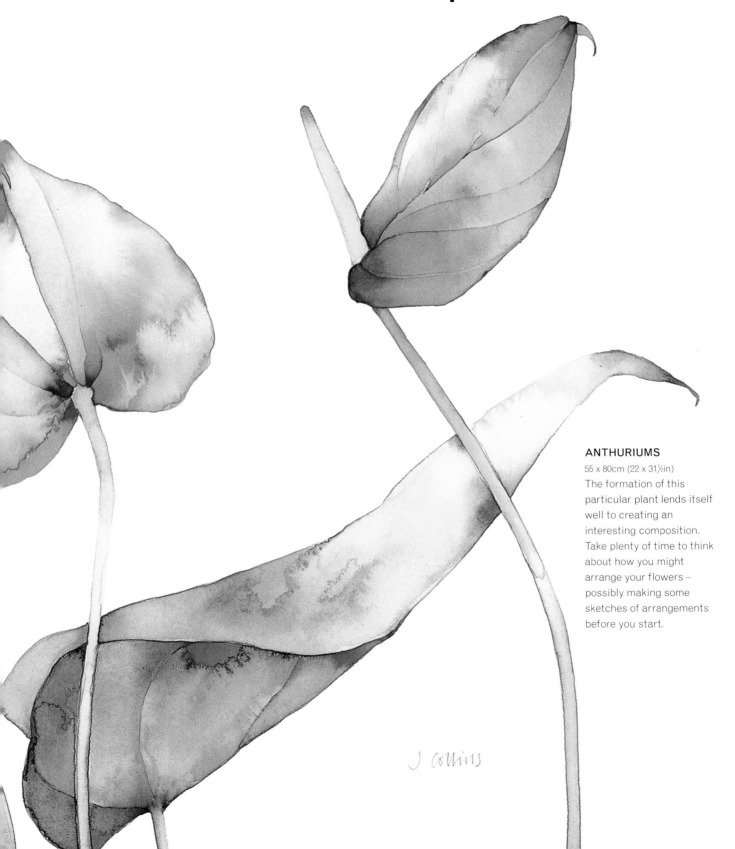

J Collins

ANTHURIUMS
55 x 80cm (22 x 31½in)
The formation of this
particular plant lends itself
well to creating an
interesting composition.
Take plenty of time to think
about how you might
arrange your flowers –
possibly making some
sketches of arrangements
before you start.

Sketching and drawing

A plan for a painting

Because composition is incredibly important, this stage in your work is crucial – the composition can be the difference between a bad, good or fantastic piece of work. In the past I would often do a strong drawing only to find that I'd gone off the edge of the paper, as I always fill the paper, even if it's A0 size! Some planning can help to avoid this.

Before you start to draw, always take some time to get to know the plant. This involves spending a long time looking at your subject before you commit pencil to paper. Making marks doesn't take long, but it's important to give yourself time to really look and plan what you are going to draw.

If you're unsure what to include or how to lay out your composition, it is helpful to use your sketchbook to make several thumbnail sketches, which is an effective way of planning a good picture. It is all too tempting to draw the flowers exactly as they sit in the vase or holder, but don't be afraid to move them or take out some stems or leaves if it looks too cluttered.

Using layout paper and tracing paper

When you have completed your thumbnail sketches and decided on your composition, it's time to put pencil to paper. This can be quite daunting – sitting and looking at a precious blank piece of watercolour paper.

It can be useful to draw your picture onto either layout or tracing paper and then trace it down onto the watercolour paper. There are several benefits to working this way:

- People tend to relax and do a better drawing onto layout or tracing paper, as they're less worried about wasting such papers, as opposed to watercolour paper.
- If you get your composition in the wrong place or at the wrong angle, you can trace it onto the watercolour paper exactly where you want it.
- You can use the tracing again to do another version without spending more time drawing.
- You can safely rub out on tracing or layout paper, whereas you can ruin the surface of watercolour paper doing this.

OUTLINE DRAWING
14 x 10cm (5½ x 4in)
On this half-painted leaf I drew the 'outline', or contour, but did not include any tonal drawing, as I used paint to show light and shade.

Using a sketchbook

Sketching is a different kind of activity from aiming to produce a finished piece. This may sound obvious, but it's something easily forgotten. From my schooldays to my late twenties I was an avid sketcher, being almost obsessive about not being able to go anywhere without a sketchbook. The sketching obsession resulted in mountains of books full of ideas, experiments or a quick record of a view or some figures that I'd seen, as well as copious notes about all the exhibitions I'd visited. During one summer I went out sketching every single day, and even spent one evening while it was dark drawing on a promenade in the Isle of Man.

This isn't to say that you need to sketch this much, but using a sketchbook makes a refreshing change from working inside – and although it can be very useful to take photographs to record images and to use for ideas, when you draw something you look and see in a different way.

Whenever I teach flower painting I encourage people to look carefully to get to know their subject before they begin, and it's true to say that when they have finished they will never look at a pansy, tulip or whatever in the same way again!

ACCURATE DETAIL
9 x 12cm (3½ x 4¾in)
Make sure that you have drawn enough information, so that you know the exact shapes of the stamens and sepals and you haven't made estimations or symbols. Also ensure that you have drawn where the stems meet leaves/flowers carefully and they aren't 'floating'.

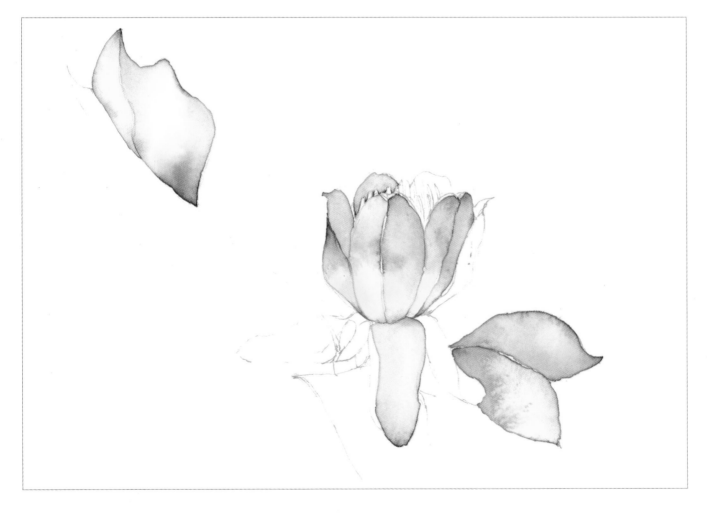

Choosing size and format

GINGER PLANT

51 x 76cm (20 x 30in)
The large size of
this flower lent itself
to a large painting.
I could have drawn
this portrait format
as a single study,
but decided that I
wanted two flowers
in the picture after
looking at the flower
for a long time and
thinking about the
composition.

Even though you may not be a botanical
illustrator, it is useful to draw your flower
life-size, as this helps with the measuring
and marking to achieve an accurate
drawing. In addition, some plants and
flowers look strange if they're not drawn
the size they actually are – especially if
they are drawn smaller than life.

The choice of format for your picture
will partly depend on the flowers you are
depicting. If you are drawing a single study
of something tall like a tulip, this will
obviously be portrait format, as will many
other flowers and leaves. However, if you are
drawing a more complicated piece, with
multiple stems, then you have a lot more
scope to use different formats. Spend time
thinking about crops and positions, as it is
crucial to your composition.

Dealing with a blank background

All the step-by-step projects and most of
the 'Gallery' paintings of flowers in this
book have no painted background –
instead, they use the white 'background'
of the paper.

To enable you to 'see' your subject and
arrange a composition, you can place your
flowers or plant in front of a plain wall, or
stand a piece of white or cream paper behind
it. This will help you decide on your
composition and look at your subject more
clearly, without the possible distraction of

a 'background' that you're not going to
include, such as kitchen utensils, patterned
wallpaper or a bookcase – in fact, pretty well
anything – behind the flowers.

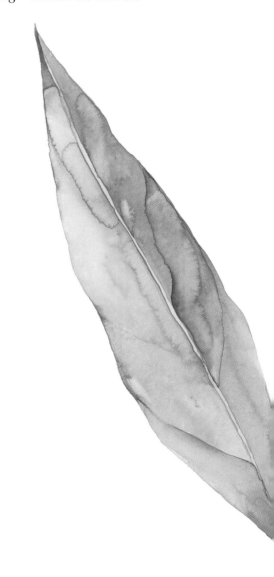

When dealing with a single study of a flower, it can be very helpful to lay the flower down flat on a piece of white paper, which again makes it much easier to 'see'. Then, when you've got to know your subject, place it in a vase ready to be drawn or painted. In addition, the flower can be moved back onto the paper if you need to study it closely again – this is also useful, as it slows down your painting process, giving you time in between each stage to consider what you're doing and to make changes if you feel these to be necessary.

Making basic marks on paper

Observation

When I realized that I was too concerned with painting a flower to look exactly like the real thing rather than relaxing, looking carefully and then drawing, I made a major breakthrough. What I mean by this is that we all need to learn to see – because we are familiar with the way things should appear, it is tempting to make marks and use symbols that are estimations of what is actually there. Forget what you expect to see and observe the shapes and patterns with fresh, analytical eyes.

Measuring and marking

When I am ready to begin drawing, after spending a long time looking at the subject and deciding on the format of the piece and on the composition and so on, I begin by making some very light marks and dots to map out where I intend to draw. (This also helps stop me roaming off the edge of the paper.) First I mark the very top and sides of

the flower, sometimes using a pencil to measure the size of the actual petal, to make sure it has been drawn the correct size.

Contour drawing

Contour drawing is a satisfying and successful method of working, as this type of drawing helps you to concentrate on one thing at a time and not to get caught up with texture, detail or light and shade too soon in the process of your work. Looking carefully and recording the contour of your subject will tell you a great deal about the character of the flower.

PROTEA COMPOSITION

51 x 76cm (20 x 30in)

This is a good example of negative shapes. When I drew this piece I used the negative shapes between the leaves to place them properly. This is particularly useful for complicated flowers and plants, where you could easily become muddled in your drawing and start making estimations instead of observing the plant carefully. I also measure and mark to ensure the top of each flower ends up exactly where I want it.

Negative shapes

Looking for negative shapes can be very useful when drawing, as is drawing the shapes between each petal, rather than one petal at a time. Using this method tends to get the petals in the correct place, whereas if you draw one at a time, very often you have too much or too little room for the last one, and may have to start again.

Deciding what to put in and leave out

This is one of the million-dollar questions about composing a picture. Just because a plant has 25 leaves at its base doesn't mean they should all be included in your picture. Less is often more, and if including three leaves rather than 25 makes a better picture, then that's what to do.

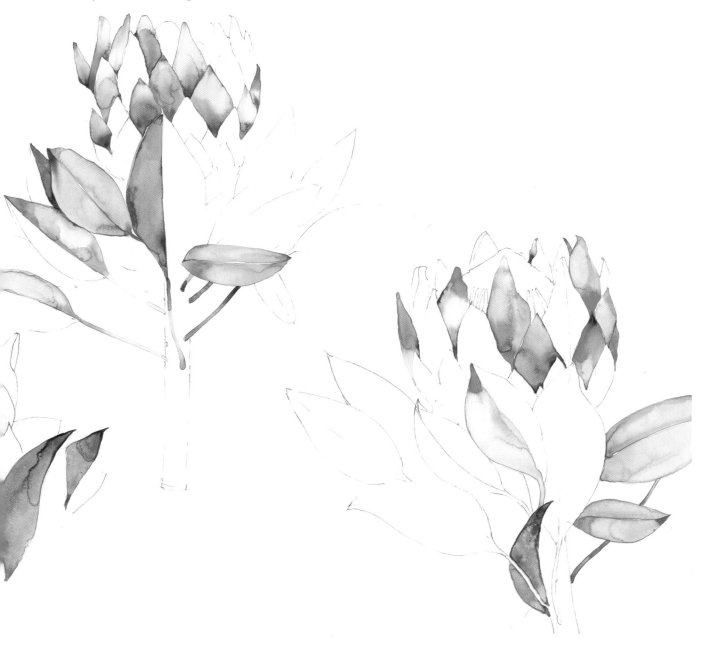

PROJECT: SINGLE FLOWER STUDY

MATERIALS
Pencils
3H pencil

Paper
Cotman 300gsm (140lb)
NOT watercolour

Additional equipment
Kneaded putty eraser

Although I normally depict flowers roughly life-size in my work, fuchsias come up very well when drawn larger than life. This is partly to do with the particular shape of the flower – but working large can be easier than drawing very small subjects! To me the fuchsia is like a ballerina – the petals are the skirt, and the stamens are the elegant legs with pointed toes – and it has great style and makes a good subject.

Drawing a single study is obviously much easier than a complex composition, but you should still take plenty of time to consider where to place the flower on the paper, how much stem to show, and so on. Using negative shapes to create the picture means that you can get carried away with looking and drawing, rather than worrying about whether it is 'right' or not.

Tip
If the stem is very thin, consider drawing it as just one line.

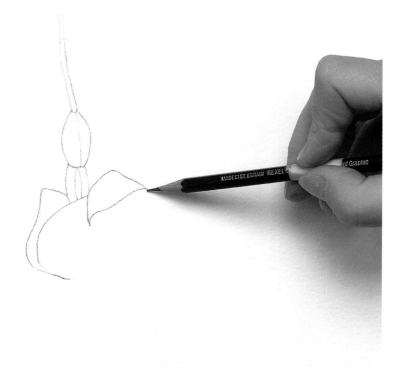

1 I started by observing and drawing the stem, being careful to note the proportions accurately even at such an early stage, as this is the setting for the rest of the drawing. From this I worked into the 'body' of the flower and into the first petals, looking for the lines and edges. While setting these early marks, you can use the eraser as a creative tool as well as a corrective one.

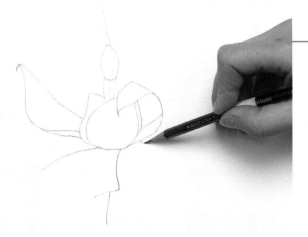

2 I added the internal edges of the petal before moving and joining them at the edge of the flower – all the time checking that the dimensions, position and proportions were right as I brought in the first long edge of the petal on the left, including the tiny curl at its tip. I marked the edge of the bottom petal and drew the lowest left-hand petal to it.

3 After measuring for the largest low right-hand petal, I joined the bottom edge lightly and built it up when I was happy with it. I then added the lower left-hand petal shapes, concentrating purely on the outlines and using the negative shapes to blend in with the positive ones for each petal shape. After moving across to build up the right-hand petals in the central area, I then worked on the furthest right petals.

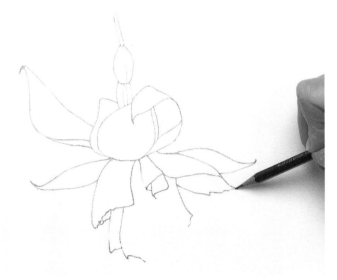

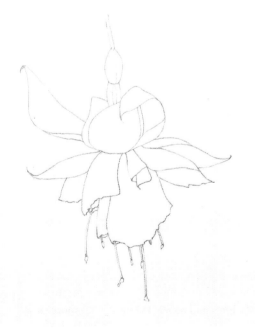

4 The stamen was very thin, and could be drawn as just a single line or two narrow ones. I made sure that I was drawing what I saw, not what I thought I saw, and used the eraser and redrew as required – you must be prepared to do this at every stage of a drawing. When everything was in place, I reinforced some of the thinnest and faintest lines.

PROJECT: COMPLEX FLOWER STUDY

MATERIALS
Pencils
3H pencil

Paper
Cotman 300gsm (140lb)
NOT watercolour

Additional equipment
Kneaded putty eraser

It took some deliberation to choose which flower to use for this exercise. Many flowers would have worked well, but I came across a display of cyclamens at a garden centre, which reminded me of a painting I did several years ago: I'd particularly enjoyed drawing the lively shapes and the petals that twisted and turned. As with fuchsias, the curves of cyclamen petals are fascinating.

There is a lot to consider – for instance, I would never show the plant in its entirety, which means there is a lot of editing to do. Examining the plant from every angle helped me decide which flowers and leaves to include, and what angle they should face. The primary concern was to make a good picture, with one flower balanced against another across the page.

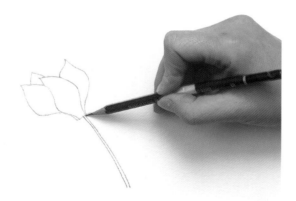

1 Before putting pencil to paper I decided where the limits of the drawing would be, and only then made tiny marks at these points. I started with the left-hand petal – because I had to start somewhere, but for no other reason – found its shape and then used it to establish the other petals in the flower, and added the stem.

2 As I moved onto the next flower I used the negative shape between it and the first flower to set its position and shape accurately – the petals were not the same, and any short cuts would stand out. The next flower to be tackled, the highest one, would have to stand in isolation until I could work down and relate it to the rest of the composition.

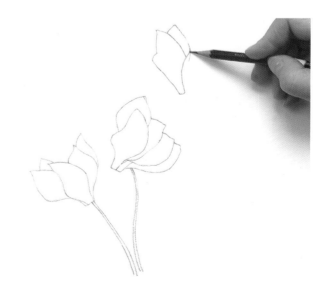

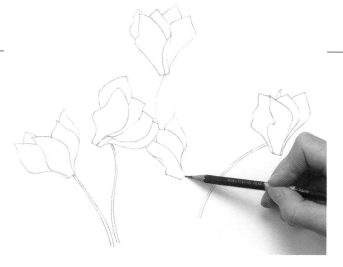

3 I added petals to the highest flower and brought its stem down to the lower flowers before working on the furthest right-hand flower, which had to relate to the rest of the drawing, even in isolation. I looked hard at the curved stem before setting down its shape. The first of the petals in the central area was the starting point for my being able to really use the positive and negative shapes to pull the composition together.

4 Now I could work on establishing the patterns of the petals and stems. The next flower's petals were quite tight and the stem met the one at far right in the drawing; I put in the first leaf as a setting point for the heart shape, and included the stem of the leaf before repeating the process for the next flower and leaf.

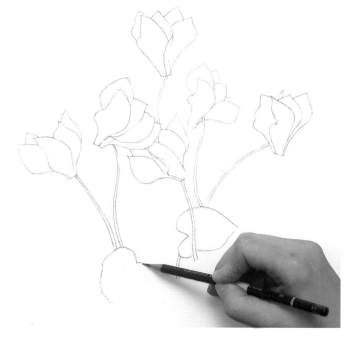

5 I added more leaves along the bottom of the drawing, again working with both the negative and positive shapes and looking for the patterns. In the central area, some flowers and stems went in front of the stems as well as behind them. After working out to the sides, I took a long hard look at what I had done and made last adjustments and amendments.

The Flowers

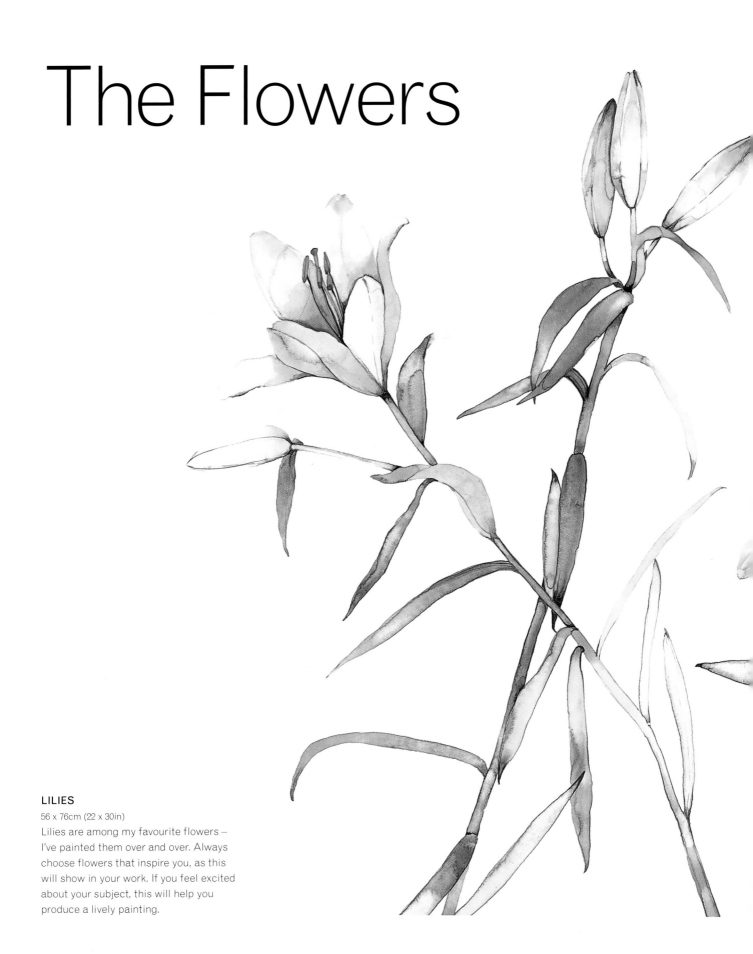

LILIES

56 x 76cm (22 x 30in)

Lilies are among my favourite flowers –
I've painted them over and over. Always
choose flowers that inspire you, as this
will show in your work. If you feel excited
about your subject, this will help you
produce a lively painting.

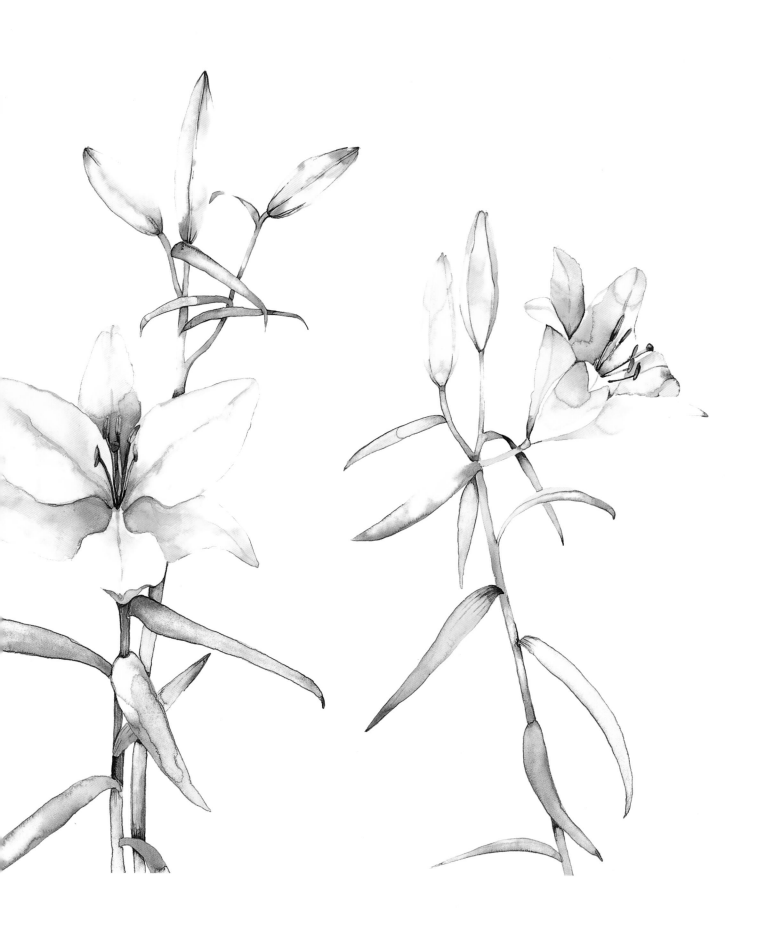

Choosing what to paint

IRIS

18 x 11cm (7 x 4¼in)
I never tire of
painting irises.
If you find certain
flowers attractive,
your response to
them will show in
your work – because
I like irises, I know
I paint them in a
more considered
and sympathetic
way than flowers
that I like less.

The most important thing for any artist is to paint what you like. If you don't like your subject this will show, and you won't enjoy the painting. One lady I teach can't stand red flowers, and if she tries to forget this and chooses a red flower it's never as good as her other work, and she always gets extremely frustrated along the way.

The next thing is not to bite off more than you can chew; for example, when I started out painting watercolour flowers, my pieces of work were all 12.5 x 17.8cm (5 x 7in). I painted this size for a long time, and

only when I felt more confident did I increase to 17.8 x 28cm (7 x 11in) and so on – I didn't start out by painting flowers on large sheets of watercolour paper.

Although it has been emphasized that you should paint what you like, it is also wise to choose simple flowers and compositions to start with, especially if you want to paint freely. Don't choose flowers with minute petals, such as Michaelmas daisies, if you want to paint wet-in-wet, as there simply isn't enough room on the plant.

Flowers change quickly

There's no avoiding this fact of life – I wish there were, as it's something students mention regularly.

Decide on the direction that the light will fall on your plant before you begin your painting and keep this consistent, whatever

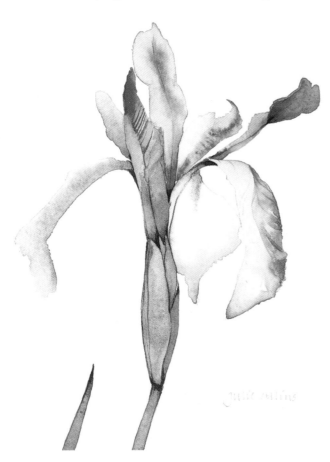

CARING FOR YOUR FLOWERS WHILE YOU PAINT

- Keep the plant well watered, and don't allow it to dry out.
- Keep the plant in a cool, dark place while you aren't working from it.
- Place a small stick or a pencil in the pot to act as a stake for your plant and keep it upright and in the same position. You can use a small amount of masking tape to keep it in place.
- Make sure you have several of the same flowers or plants in case the one you are using dies.

changes occur to the flower. Don't get too upset if the flower subsequently moves with the light, opens out more or, worse still, droops. Too often people can get disheartened if this happens, but this may have more to do with feeling apprehensive about painting, rather than the change in the plant being a truly insurmountable problem.

If you have achieved a clear and believable drawing and studied your plant well, you will still be able to paint it convincingly, even if it moves.

Mixing colours for pansies

The chart below shows the mixes I used for the project on page 58, and is a good demonstration of the fact that you don't need a massive amount of colours to achieve a whole range of realistic and exciting shades. I used nine.

The palette is: Winsor violet, permanent rose, alizarin crimson, ultramarine, cobalt blue, new gamboge yellow, cadmium orange, lemon yellow and burnt sienna.

The first horizontal row is the base colour of the mix – the annotations 'more' and 'less' describe the varying amounts of pigment used (this will obviously vary from mix to mix). The next horizontal line shows the second colour in the mix, and there is one third colour.

The final horizontal row gives the result of the mixing processes, and are the colours that were used for the project. Experiment with mixing the colours (see page 32), and keep a record of the mixes that have worked best for you.

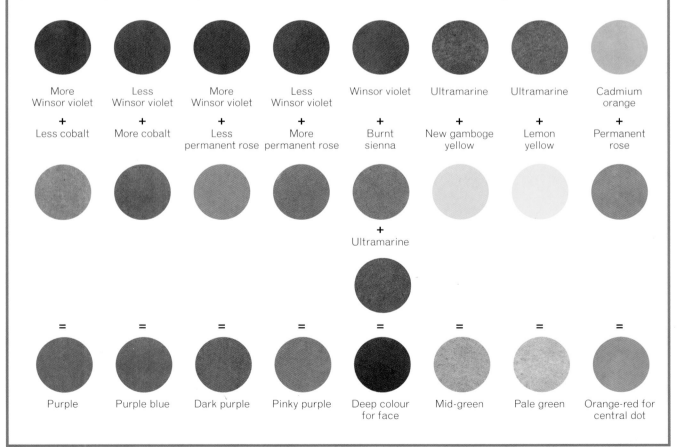

More Winsor violet	Less Winsor violet	More Winsor violet	Less Winsor violet	Winsor violet	Ultramarine	Ultramarine	Cadmium orange
+	+	+	+	+	+	+	+
Less cobalt	More cobalt	Less permanent rose	More permanent rose	Burnt sienna	New gamboge yellow	Lemon yellow	Permanent rose

				+			
				Ultramarine			

=	=	=	=	=	=	=	=
Purple	Purple blue	Dark purple	Pinky purple	Deep colour for face	Mid-green	Pale green	Orange-red for central dot

PROJECT: ROW OF PANSIES

MATERIALS
Pencils
3H pencil
Watercolour

Winsor violet

Cobalt blue

Permanent rose

New gamboge yellow

Burnt sienna

Ultramarine

Lemon yellow

Cadmium orange

Brushes
Nos. 6, 4, 2, 1 round
No. 0 or 00 round

Paper
Saunders Waterford HP
300gsm (140lb)

Additional equipment
Kneaded putty eraser
Small board

With their happy faces, pansies invariably seem cheerful. I always enjoy painting them, and they are always popular with students. Their depth of colours and heavily marked faces lend themselves to bold painting, at the same time remaining quite delicate. Pansies are ideal for painting wet-into-wet: their fairly large petals give you room to be free with the paint and get plenty on in the first wash. One pansy is manageable when your time is limited, but several make a successful, complex composition.

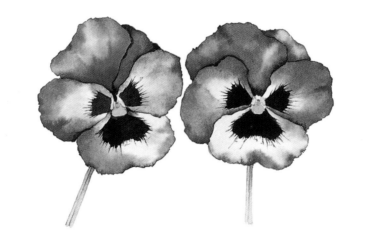

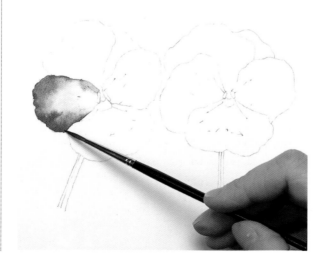

1 I arranged three separate pansies to find the best composition, then lightly drew them directly onto the paper – I slightly thickened the lines for photographic purposes, then lightened them again with an eraser before painting. You can use tracing or layout paper to fix the shapes and relationships (see page 44).

After taking a good look at the flowers, I made up two medium-strength mixes of Winsor violet and cobalt blue – one tending towards purple, the other more blue – and tested them on scrap paper. I applied clean water to the area to be painted on one petal with a No. 6 brush, allowed it to dry until it was 'shiny wet', then applied the bluer mix with a No. 4 brush. Before this dried I added the darkest areas in purple with a No. 2 brush.

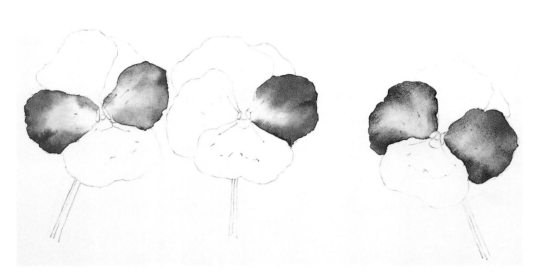

2 I repeated this process on the opposite petal to the first, so as not to spill over onto the wet paint; if you do this, look hard at each individual petal and vary the strength and colours of the mixes to suit it. As each petal dried a little more, I used a No. 1 brush to add the darker edges and shadow areas.

Tip
Practice, and lots of it, is the key to working this wet-into-wet; you'll use a fair amount of scrap paper, but the results are worth it.

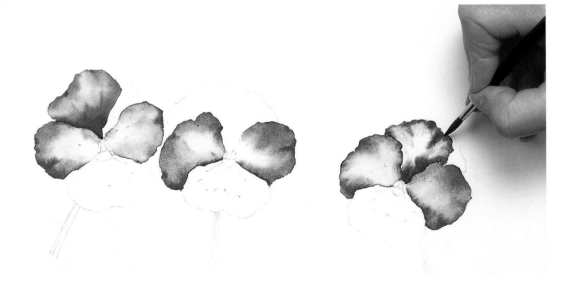

3 For the back left-hand petal I made two mixes of permanent rose and the purple mix, one more pink, the other more purple. I then used the latter with a No. 4 brush for the bulk of the petal, switching to a No. 2 and the pinker mix for the edge and details. The No. 1 was useful for suggesting the directions of the folds and veins without going into detail. The next stage was to work across more of the petals, varying the mix colours and being careful not to bleed into wet areas.

Project: Row of Pansies

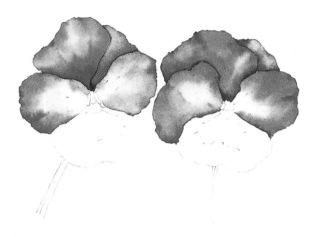

4 After painting the last main petal at the back, I allowed all the petals to dry before wetting the very back petals – because these are in shadow and are smaller and therefore darker, the mixes were used stronger and I could go quite dark towards the centre of each flower. Everything was allowed to dry thoroughly.

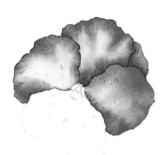

5 On the front petals I made sure not to paint water onto the central area, leaving it for the yellow later. There was marginally more contrast between the petal shades and colours here, so I switched between the mixes to reflect this; I used a light wash where I would go dark later. Again, I let everything dry completely.

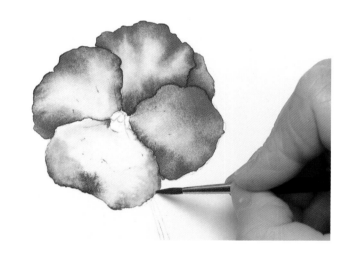

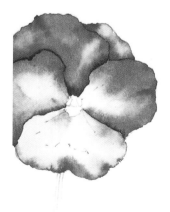

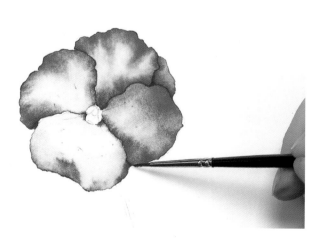

6 For the shadows where one petal met another and they were tonally the same, I made a very strong mix of Winsor violet, new gamboge yellow and burnt sienna, and used a little paint on a No. 1 brush to put in the darker lines. I then added a little more water to the mix and blended out the paint to give one hard edge and a softer 'line' away from it.

7 For the darkest part of the flower – the 'face' of the pansy – I made up a large, strong mix of Winsor violet, burnt sienna and ultramarine: this was large because it would have been very hard to match a mix if I ran out, and it was dark because otherwise I couldn't get the effect I was after. I used a No. 4 brush for the first application, and switched to a No. 0 to radiate the lines out from the main area of colour before allowing the paint to dry completely.

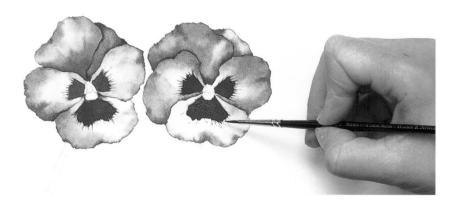

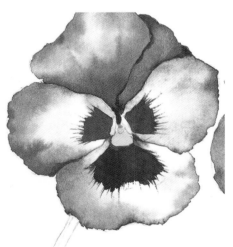

8 For the centres of the flowers I first wet the side patches and applied a very pale wash of Winsor lemon with a No. 0 brush, allowed it to dry and then used new gamboge yellow on the lower part, working with a dryish brush for strength of colour. When this was dry, I mixed Winsor lemon and ultramarine to make a lime green for above the yellow, and again when dry, mixed permanent rose and cadmium orange for the very centre.

Tip
When working with many colours for the centres of flowers, as here, it is vital to allow each layer to dry thoroughly, as any colour runs here could ruin the painting at a later stage.

9 The finishing touch was to paint the stems; each has a lighter 'side', so I started by applying clean water to this with a No. 2 brush, adding a mix of ultramarine and new gamboge yellow and then one of ultramarine and Winsor lemon to it. I made variations in this small area with a No. 0 brush, allowed the area to dry, then painted the darker 'side' with a slightly darker mix of Winsor lemon and ultramarine.

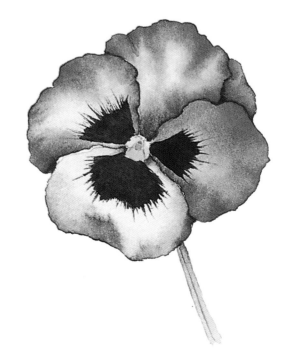

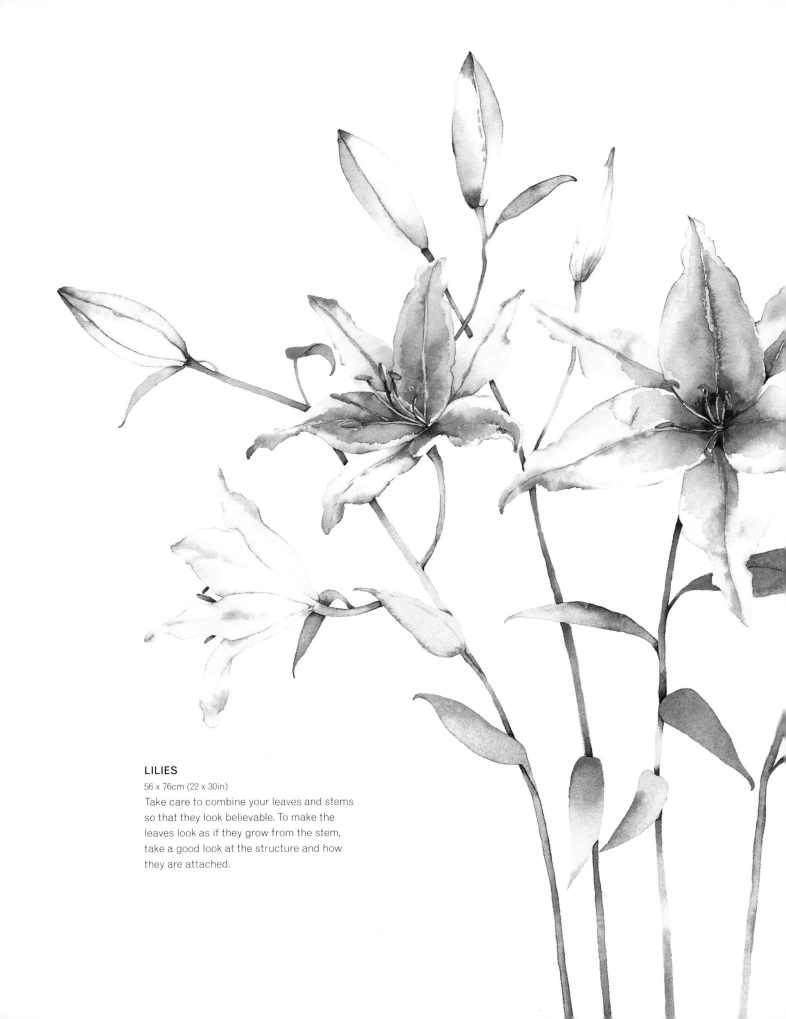

LILIES

56 x 76cm (22 x 30in)
Take care to combine your leaves and stems
so that they look believable. To make the
leaves look as if they grow from the stem,
take a good look at the structure and how
they are attached.

Leaves and Stems

Combining leaves and stems

Opposite:
CARDOON

56 x 38cm (22 x 15in)
The greatest
proportion of
this painting is
comprised of
leaves and stems,
so I had to spend a
lot of time thinking
about how these
join onto one
another, as the
structure is a
crucial part of
the composition.

Leaves

When you begin to paint leaves as studies in their own right, rather than part of a flower painting, you begin to see them in a different light. Of course, this is much easier to see if you're painting large leaves like the cardoon opposite: the sheer scale of the leaf is inspiring enough, let alone the amount of interesting variations in a leaf this size.

Being faced with a sea of small, fiddly leaves, particularly round or oval ones, may leave you cold. In this case, edit the mass and only include enough leaves to enhance the composition, so that you can enjoy the painting, rather than feeling overwhelmed. I prefer to paint plants with larger leaves, such as tulips – a tulip leaf is full of character and gives plenty of room to get a lot of paint on. When painting smaller leaves, I use the same technique as for larger ones, only with smaller brushes.

Sometimes you can include veins, and at other times not. Generally the criterion I use to decide is whether veins will add something to the picture – when painting strelitzia, I feel that the shapes that some of the veins make on the leaves add interest to the composition. If you include veins, make sure that you've really looked at their shapes and whether they curve or are quite straight; in addition, don't make them too thick or rigid, otherwise they can end up looking unrealistic and as if they don't belong to the leaf.

Painting a series of autumn leaves is another way to see leaves in a different light. Autumn and winter palettes can be very inspiring – and if you feel inspired you're halfway there. During a class one lady was amazed when she looked at her autumn leaf through a magnifying glass, which helped her to see the fantastic colours and shapes. Using pressed leaves means you have plenty of time to draw and paint your leaf, and it won't move, wilt or curl.

At another course I was explaining about drawing when someone asked, 'Why don't we just lay the leaf down on the paper and draw round it?' I'm still not sure whether she was joking or not, but I replied that if you use a stencil you miss out on the particular marks you make when you draw – which are a major part of the character of your work.

ACHIEVING VIBRANT LEAVES

- Edit leaves only after a lot of consideration and observation.
- Choose to paint plants/flowers with leaves that you like.
- If appropriate to your style, you can paint the leaves as an 'impression'.
- Make studies of leaves that you like on their own – not as part of the plant.
- Mix plenty of greens (see pages 26 and 28).
- Use the right-sized brush for the leaf.
- Look at veins carefully before painting.
- Practise veins on scrap paper.
- You can paint flowers without leaves.

Stems

It's as important to get interest into the stems as well as the leaves and flowers. If you've included various colours, shadows and some detail in your leaves, the stems should be painted along the same lines. However, if you've painted the leaves in a more simplistic way – as if you were painting an impression of the plant – then the stems can be simple, too.

When you draw, ask yourself what shape the stems are. The stem is as much part of the character of the plant as the flower – and stems are all different. The first time I painted a pansy I was amazed that the stem had square sides; to be honest, I was more amazed that I'd never noticed this before, particularly as I'd been growing pansies in pots for years and consider myself to be observant! I was also surprised to see that the stem is thinner at the top, where it joins the flower, than it is further down.

One of the main problems with stems is making them too wide. This doesn't happen now when I draw them, as I always look carefully to check their width, but sometimes things go pear-shaped when I apply the paint. This most often happens when painting very wet, and if I'm not

careful the paint can go over the edges of my drawing. This can be avoided by using the most appropriate size of brush for the stem I'm painting, and applying the right amount of paint. In classes I encourage people to practise their stems on a rough piece of paper before committing themselves to the real thing – this doesn't take long but gets you into the swing of painting stems, which can be so different from the rest of the plant.

To make your stems look believable, make sure they join up with each other, the leaves and the flowers. If they don't you end up with 'floating stems', which don't make any sense and are also very difficult to paint, as you haven't got enough information about how and where they join.

PAINTING SUCCESSFUL STEMS

- Take care to join up stems.
- In your drawing, make sure you get the stem the correct width.
- Mix plenty of paint.
- Use as varied a palette as you do for leaves.
- Practise first on scrap paper.
- Try out different-sized brushes to see which will work best.
- Before painting, decide which side the light is coming from.

PROJECT: HELLEBORE

MATERIALS

Pencils
4H pencil

Watercolour

Lemon yellow

Hooker's green

Yellow ochre

Alizarin crimson

Winsor violet

Viridian

Burnt sienna

Indian red

Ultramarine

Brushes
Nos. 6, 4, 3, 2, 0 and
000 round

Paper
Saunders Waterford HP
320gsm (160lb)

Additional equipment
Kneaded putty eraser

There are so many good things to say about the hellebore: it's a smart plant; it lifts the spirits in winter, as it is a welcome surprise in an otherwise dull and dormant garden – although before I planted the first hellebore in my garden I was under the illusion that the plants are difficult to grow and would elude me forever.

From a painter's point of view, the structure and pattern of the hellebore are fabulous, and the subtle markings on the flowers, stems and leaves are exciting to paint. Hellebores come in an amazing array of colours, from blue-black to ivory, with so many varieties in between. Their colours are well co-ordinated and subtle rather than brash; and finally, the hellebore lends itself to good composition, which should satisfy one of your main pictorial concerns.

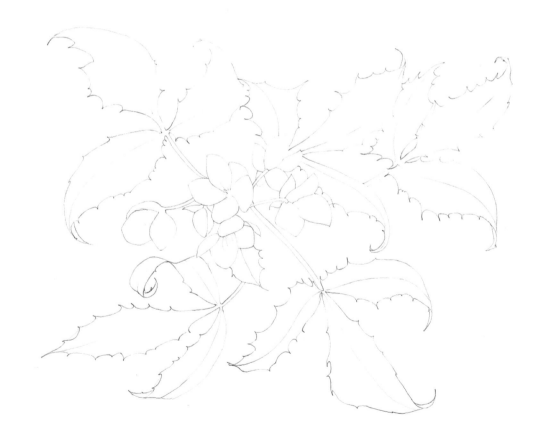

1 I made the initial drawing in 4H pencil, concentrating on the way the leaves curl as well as on the shapes. I also paid attention to the irregular spikes, looking at their shapes, sizes and directions away from the leaves.

2 Because the veins and tips have a similar light colour, I decided to put an establishing wash over each whole leaf area, applying a very watery first mix of lemon yellow and Hooker's green with a No. 6 round brush. On other leaves I applied another watery mix, this time using a No. 4 round brush and a mix of yellow ochre and lemon yellow; and then switched to a No. 0 round for the red on the tips, using alizarin crimson with a tiny amount of Winsor violet while the first wash was still wet.

Tip
If you don't like to work quickly, paint just half of each leaf with wash before adding the red tips; and do any folded-over leaves in two parts – first the lighter front part, then the darker part when the first wash is dry.

3 I continued to paint the leaves, alternating between the two base washes for variety but using more of the acid lemon yellow and Hooker's green wash overall. I also felt free to add more yellow or green to each mix as I felt necessary. Everything was then left until it was completely dry.

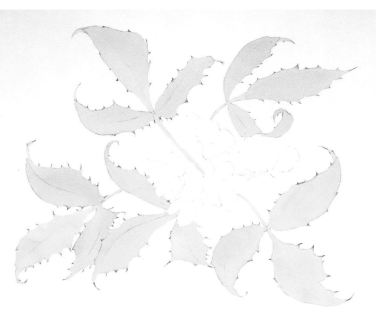

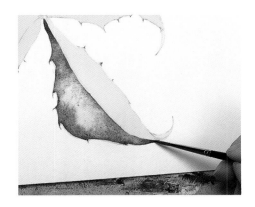

4 For the next layers of glaze, I made up quite strong mixes of viridian and Winsor violet; viridian and burnt sienna; two mixes of viridian and Indian red, one darker than the other; and ultramarine and burnt sienna. Half a leaf at a time, I painted clean water onto the dried first wash, keeping clear of the edge or the stalk or veins, then painted the viridian and Indian red mix onto it using the No. 2 round brush. I continued to add the colours I could see, with the grey ultramarine and burnt sienna mix towards the edges. I made a point of being able to still see some of the first wash underneath this one.

Project: Hellebore

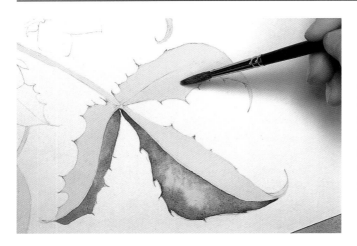

5 I used the viridian and burnt sienna mix for where the leaves curl over, and repeated everything on the 'first' half of all the leaves; when these washes were dry I started on the other halves, always looking at what was there in the subject and not assuming that the other half would be the same as, or similar to, the first half.

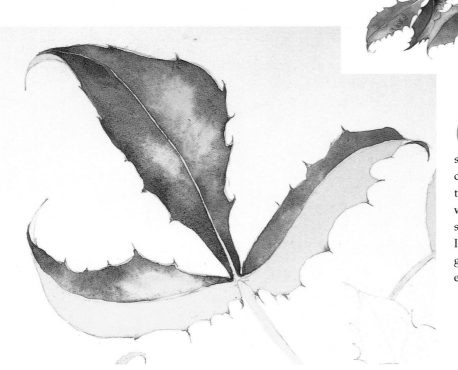

6 As I continued to paint the leaves, I allowed each half of the group to dry completely before starting on the other half, then worked carefully to ensure that the stems into the leaves remained visible as the first wash; I went quite dark with these second washes.

INSET ABOVE: I alternated between the green mixes and attempted to keep everything fluid yet a little controlled.

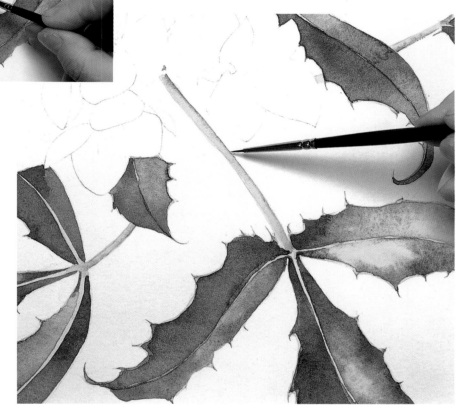

7 The stems have as much variety as the leaves. I used a No. 2 round brush to wet each stem and applied a more lime-green version of the lemon yellow and Hooker's green mix (to the same dilution), plus alizarin crimson mixed with a little Winsor violet for the red tinges. To indicate the square section on the shadow side of the stem I used a No. 0 round brush to apply a very watered down viridian and burnt sienna mix. INSET ABOVE: When the stems were almost dry, I used a No. 000 brush to put in the fine details where the leaves met the stems.

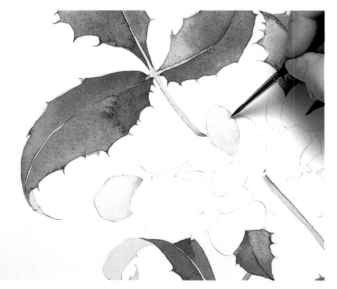

8 On the flowers I used an extremely diluted mix of yellow ochre and lemon yellow to wet the paper instead of water – this helps to keep the colours of the washes fresh. I used Nos. 4 and 2 brushes to apply the pale underwash and a slightly darker mix of viridian and lemon yellow over one petal at a time; this was then followed by touches of this darker mix to give depth of colour and suggest shadows that also made contours. I used a tissue to dab off excess water on all these washes.

Project: Hellebore

9 The colours of the flower stems, which also go out around the petals and 'hold' them, are the same as the leaves, without the red tinges. I painted the stems when the leaves and flowers were completely dry, using the same brushes, and added a few darker washes to the longest leaf stem, as this helps to place the lights and darks in the central area.

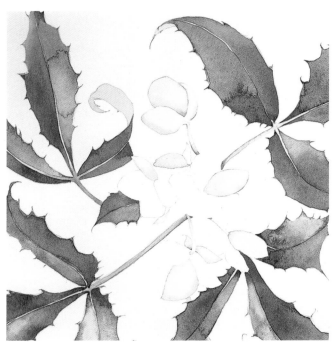

10 With most of the picture now established, I continued to apply the basic colours of the flowers and stems, looking for the relationships between adjoining areas. It's important to get the shadow colours in while the washes below are wet, as this adds depth – if they dry, the shadows can look flat.

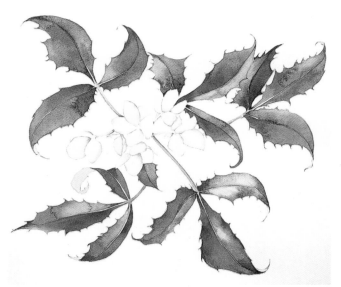

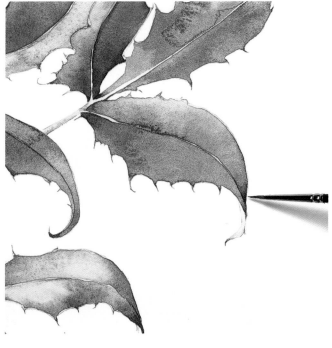

11 When the leaves were dry, I added the shadows to them, using a strong mix of viridian and Indian red with a No. 0 brush; I worked wet-on-dry and gently blended the darkest parts into the rest of the leaves, looking to find the main tones and contrasts – here, where the leaves curl and where they join the stems.

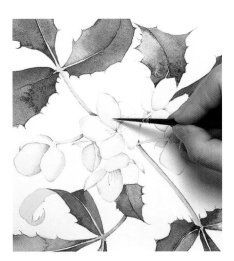

12 Now I concentrated on the details and intensified the reds where I felt necessary. For the shadows on the leaves I used a No. 0 brush to apply the lime green mix with a tiny amount of burnt sienna added, working wet on dry with tiny strokes. After boosting the colour of the stems using darker versions of the establishing mixes, I finished with the centre of the flowers, using Nos. 0 and 000 brushes to apply a viridian and Winsor violet wash and light and dark mixes of viridian and Indian red.

Tip
To find tones and contrasts when a painting is quite advanced, narrow your eyes and squint so that everything is reduced to pure colour and tone. Any areas that still require work should be obvious with practice.

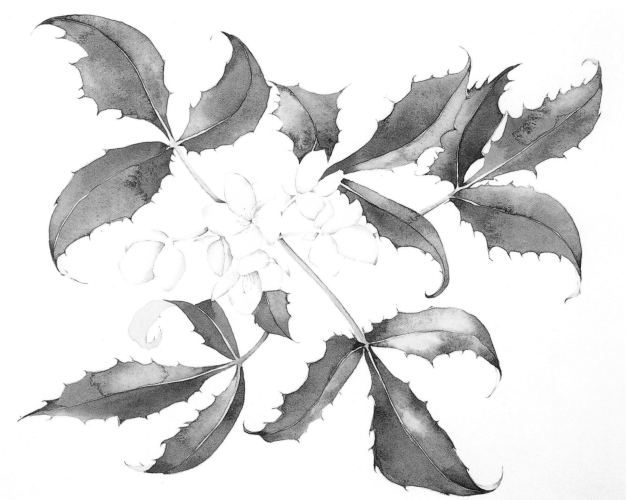

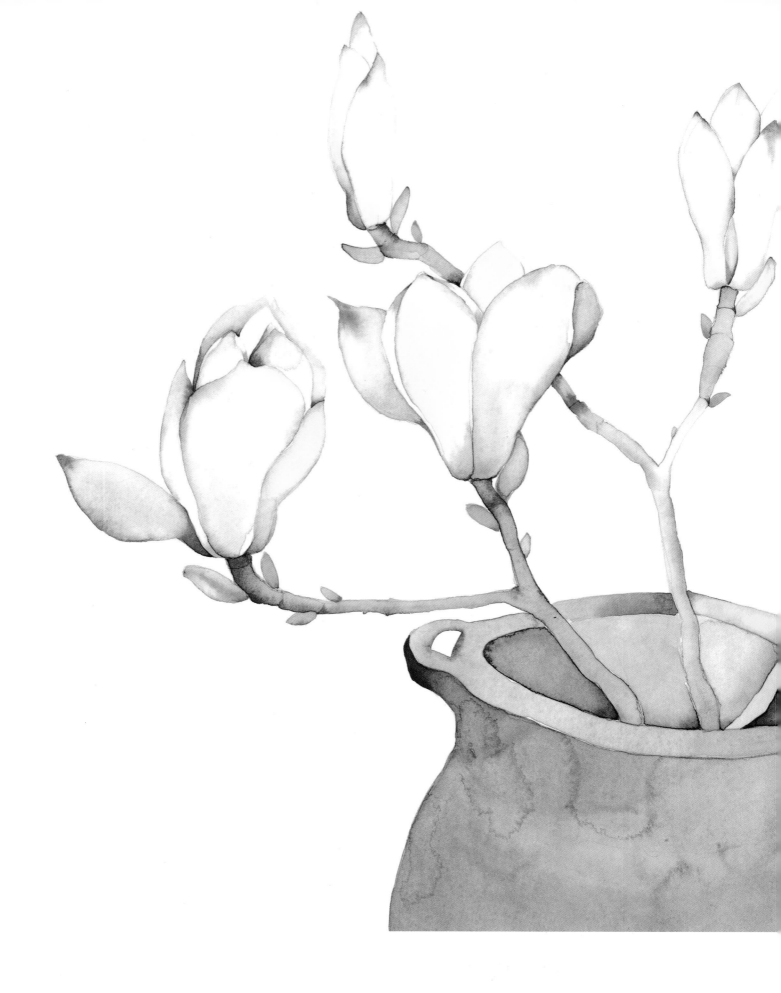

White Flowers

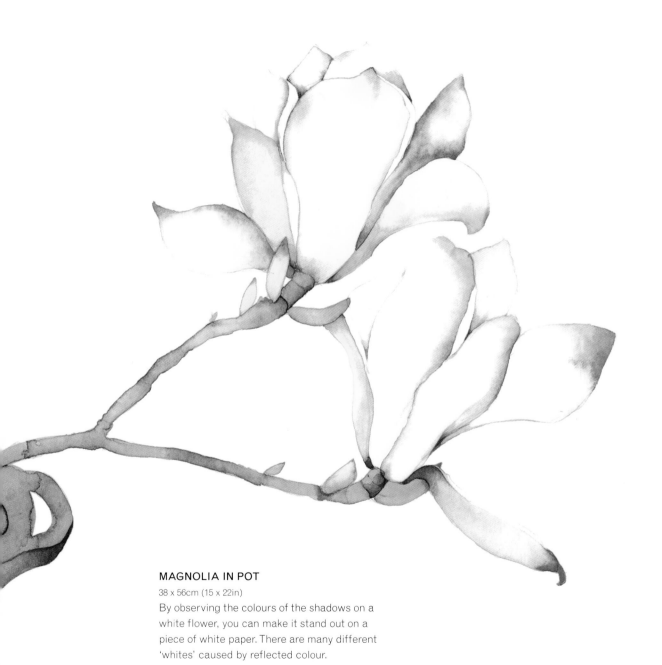

MAGNOLIA IN POT

38 x 56cm (15 x 22in)

By observing the colours of the shadows on a
white flower, you can make it stand out on a
piece of white paper. There are many different
'whites' caused by reflected colour.

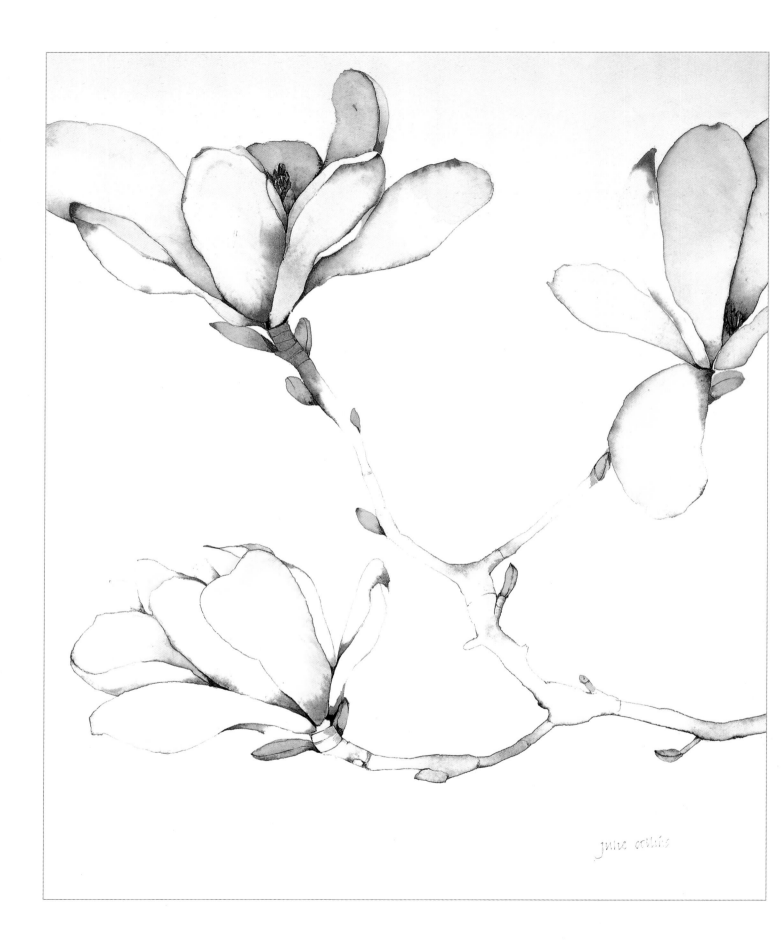

june collier

The colours of white

We tend to see white as an absence of colour. This then presents a terrible problem of how to paint white flowers. Do you just paint in a background and leave the petals the colour of the paper, or perhaps take one grey and paint all the shadows that colour?

When you look harder at any flowers, you begin to see that pale grey, blue grey and creamy yellow are all 'whites'. If you have painted winter snow scenes you will know that 'snow white' is not pure and clean as we imagine it, but is usually tinged with blue, pink and yellow, depending on the light conditions. Apply the same principle to white flowers, and you're halfway there – it's about seeing the actual colour, rather than making assumptions.

(Of course, this isn't the same for everybody: for instance, white doesn't present the same problem to me as other colours, such as yellow. I can see a lot of colours in white flowers, whereas yellow is a real struggle for me and I tend to avoid painting yellow flowers altogether.)

You don't have to go far for inspiration, either: my biggest inspiration for white flowers is one of my neighbour's magnolia trees. This is the biggest magnolia I have ever seen in a private garden, which was planted about 50 years ago and takes over half of their front garden. Every February it has the most magnificent show of white blooms that don't last very long. At this time each year I beg some flowers from the tree and paint like fury

– single blooms, clumps of flowers, a bunch in a vase or jug. The reflected colours in the magnolia are endless, and the particular shapes of the petals are excellent to paint.

A simple way to paint white flowers is to use something like Davy's grey for all the shadows. This is fine up to a point, but there are so many different greys to depict that it is a shame to resort to one colour for the whole job! Looking for the variety of greys or reflected colours is essential preparation and most of your time is better spent doing that, rather than rushing into the painting.

Thankfully, white seems to look best against greens. Next time you're in your garden, have a look to see this effect at its best, outside in natural light. So painting your white flowers against a background of green leaves or simply a green background can work well.

Opposite:
MAGNOLIA
40 x 30cm (16 x 12in)
This holds many 'subtle whites'. The petals are very pale cream in places, often with blue, lilac or pale grey shadows on the edges and folds. The centre and base of each flower can be enhanced by using stronger shadows.

USING A BACKGROUND
13 x 20cm (5⅛ x 8in)
A colourful background solves a lot of problems when painting white flowers. It complements the flowers, and pale grey shadows enhance the petals.

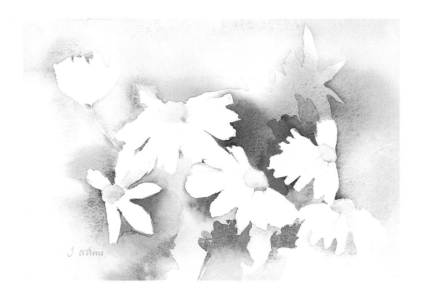

PROJECT: WHITE FLOWER ON WHITE

MATERIALS

Pencils
4H pencil

Watercolour

Cobalt blue

Burnt sienna

Indian red

Yellow ochre

Ultramarine

Hooker's green

Permanent rose

Winsor violet

New gamboge yellow

Lemon yellow

Brushes
Squirrel mop 2/0
Nos. 6, 4, 2, 0 round

Paper
Saunders Waterford HP
320gsm (160lb)

Additional equipment
Kneaded putty eraser

Choosing which white flower to paint on a white background took a lot of deliberation – with white flowers it can be quite difficult to pitch the depth of tone to use: too little and the flower looks insipid and hardly there, too much and you end up with a dull, grey flower. I wanted to present a strong image on the page to show all the colours that can be seen in a white flower and in the end I decided on a clematis, as this particular variety has quite a large flower head and also works well when drawn larger than life.

1 I used a photograph as reference for the initial drawing in 4H pencil, which I enhanced with thicker lines so it would show up here. Because it's not always possible to work from life, or perhaps when you're on holiday and you spot an exotic flower you don't see at home, taking a photograph as an *aide-mémoire* is a good idea – and doing so can also help if you want to enlarge the size of your painting.

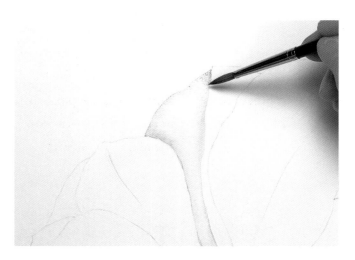

2 After wetting the area with clean water and a squirrel mop brush, I applied a very diluted mix of cobalt blue and burnt sienna with a No. 4 round brush to the left-hand side of the damp area. I then painted a mix of cobalt blue and Indian red at the tip and down the right-hand side, before working inside the other colours and using a little cobalt blue on its own. I then let everything dry thoroughly.

3 I repeated the wetting process on the opposite leaf to the first, but this time used a No. 2 round brush to get the wash of burnt sienna and ultramarine between the stamens coming out from the centre of the flower. I then used a little Hooker's green and burnt sienna mix along the edge, blending this away from the 'line', using a No. 6 round brush to soften and blend the colours into the water. Again, I let everything dry completely before continuing.

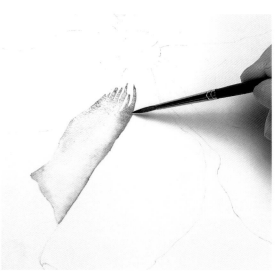

Tip
When working with such light colours, it is essential to test every wash you make up on a scrap piece of paper the same as the one you are using for the painting. Make lots of test swatches and let them all dry to see the final effect of each one.

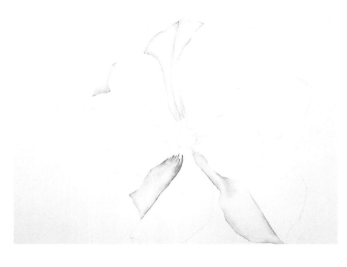

4 On the petal next to the first dry one I applied the cobalt blue and burnt sienna mix to the base, then painted yellow ochre along the left edge and cobalt blue along the right side. I alternated between the brushes, using the No. 2 to keep the colours from blending too much. After wetting a background petal, I used a cobalt blue and Indian red mix for the pink, then switched to a greyish mix of Winsor violet and burnt sienna for the other colour. On the next petal I used mixes of ultramarine and burnt sienna and of ultramarine and yellow ochre to complement the touches of Hooker's green for the shadow areas.

Project: White Flower on White

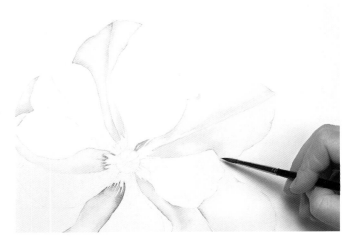

5 By now I had set the basic mixes for most of the petals, but introduced a very diluted mix of yellow ochre and permanent rose over most of the next petal. I alternated between the mixes and, as the colours dried and set the basic tonal structure, I began to work a little darker into the stamens and bases with stronger mixes. I used a little Indian red on the tip of the next petal, with yellow ochre and the ultramarine and burnt sienna mix for the rest.

6 I used a slightly darker wash of Hooker's green on the last background petal, before moving onto the first foreground petal with cobalt and a tiny amount of burnt sienna for the light shadow colour and then some Indian red. This petal is completely separated from the one behind it, as its edge curls behind itself. I was now able to regard the flower as a whole, noting that the top was much lighter in tone than the bottom; the shadows would have to work together tonally, as well as the colours.

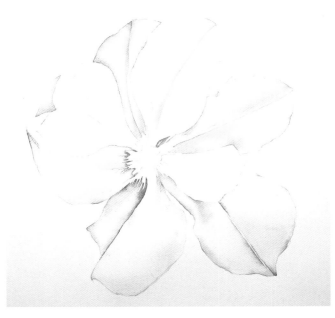

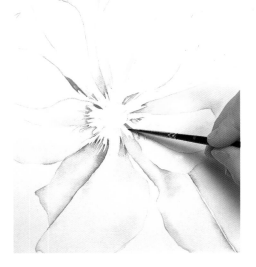

7 For the most 'forward' petals I used very light washes with the smaller brushes mostly (Nos. 2 and 4) and left some parts of the paper unpainted. To achieve the effect of sunlight in the foreground, I diluted the washes even more. I switched to a No. 0 round brush to add stronger mixes over the whole painting, working wet-on-dry and blending the colours out with clean water.

Tip
Feel free to turn the paper round as much as you need to get the right effects – you don't have to work from the same angle all the time!

8 Now I worked into the central areas between the stamens, going quite dark with the smallest brushes. The centre yellows were painted with new gamboge yellow and yellow ochre separately, plus a light mix of yellow ochre and burnt sienna. For the very centre I first wetted the area and applied a mix of lemon yellow and yellow ochre, then allowed this to dry. I used Indian red for the ends of the stamens, then I applied new gamboge yellow on the long parts – dampening the stamens beforehand kept the colours lively. I then applied a dark wash of ultramarine and burnt sienna between the petals to emphasize the white, unpainted stamen areas.

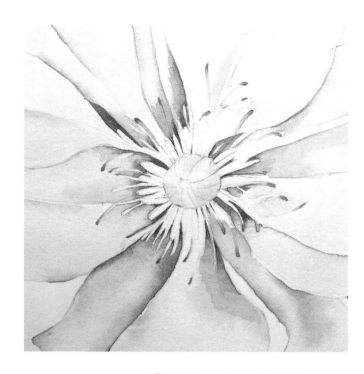

9 To bring forward the lightest parts of the lower centre and stamens, I added shadows with a mix of Indian red and ultramarine. The centre was not strong enough, so I used a yellow ochre and new gamboge yellow mix there, then applied mixed burnt sienna and ultramarine for the tiny dark spot in the very centre. With a little more yellow the painting was finished while it was still fresh and in no danger of being overworked.

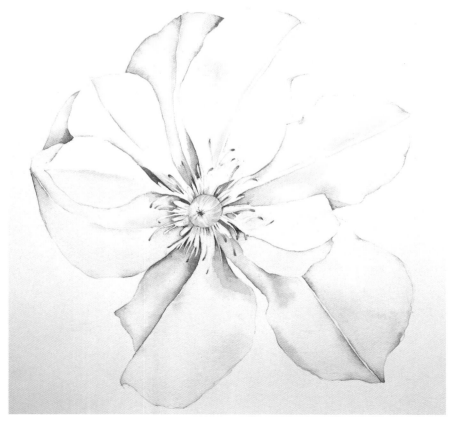

PROJECT: WHITE AGAINST GREEN

MATERIALS
Pencils
4H pencil
Watercolour

Davy's grey

Cobalt blue

Ultramarine

Yellow ochre

Viridian

Indian red

Burnt sienna

Permanent rose

New gamboge yellow

Lemon yellow

Brushes
Nos. 6, 4, 2, 0 round

Paper
Saunders Waterford
HP 320gsm (160lb)

Additional equipment
Kneaded putty eraser

Green is a wonderful backdrop to white: the richness of the greens enhances the whites and provides interesting shadows that help to depict the petals – in this case, white roses. The versatility of the green mixes meant that here I was able to rely mainly on Davy's grey for the shadows. This is one of the very few colours I use neat from my box, and is a good alternative to mixing greys each time. You can also enhance Davy's grey by adding some blue, as here.

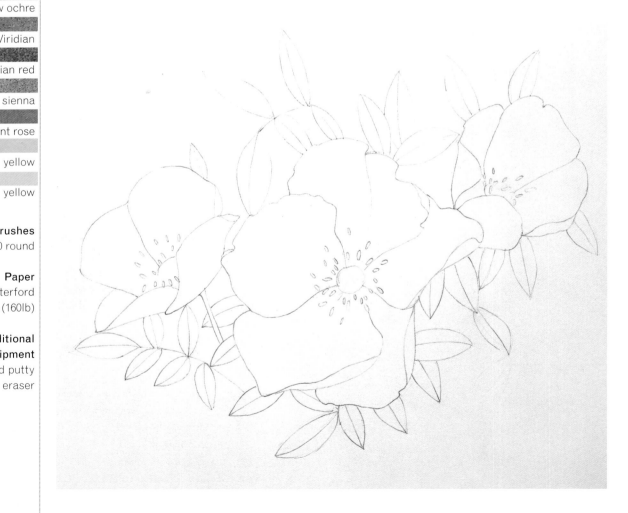

1 I made the initial drawing in 4H pencil, which I enhanced with thicker lines so it would show up in the photograph here and subsequently erased back to its original strength.

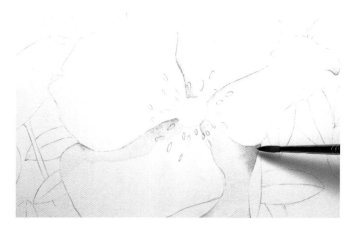

2 I made up different-strength mixes of Davy's grey to start, plus one of Davy's grey and cobalt blue for greater variety and depth. Working both wet-on-dry and into areas flooded with clean water, I used these mixes on the shadow parts where the petals overlapped, using Nos. 4 and 2 brushes. I worked outwards from the centre behind the stamens, blending in colour from the edges.

Tip
When painting folds and creases in petals and leaves, keep the colour in the edges and corners to begin with; don't go across the line of the fold, as doing so loses the sharpness, but blend out from the line to show the contours and shapes.

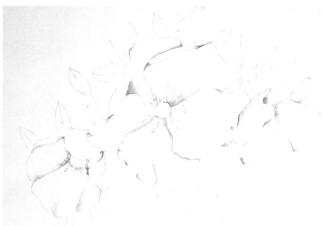

3 I left the stamen areas as negative shapes so that I could colour them in later, and used the grey and blue-grey mixes for the biggest folds and creases in the petals and where the petals fold over – those nearest the front are darker than those behind or in the rear. Once I had established each area, I could then start to go darker, working from light to dark.

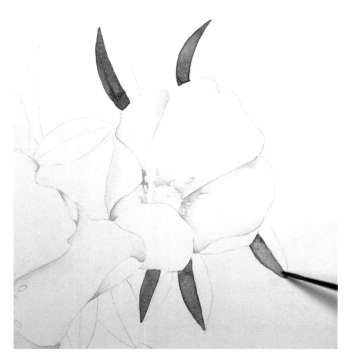

4 I took some time away from the painting itself and concentrated on observing the flowers and leaves and mixing washes in advance for the greens and reds: ultramarine and yellow ochre; viridian and ultramarine; viridian and Indian red; viridian and burnt sienna; and viridian and permanent rose. I used the first of these and then the viridian and Indian red one with Nos 6. and 4 round brushes on one half of each of the leaves, and then switched to a No. 2 round for touches of permanent rose at the tips and bases. The flowers now became negative shapes on the 'positive' leaves.

Project: White Against Green

Tip
The leaves all go in different directions, so pick out certain ones that make interesting patterns to add vitality and life to your picture.

5 As I continued with the leaves, I sought out the variations in colour and tone; I used permanent rose wet-into-wet over some of the green, and vice versa on smaller leaves, and used different green washes as well.

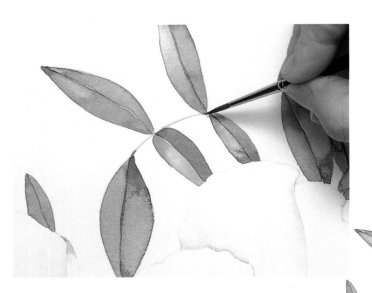

6 When each half of a leaf was dry I started on the other half, but not necessarily using the same mixes or even greens. I also looked at how the contours and directions of the leaves related to adjoining leaves; I worked wet-on-dry here, because too much water might have lost control around the negative petal shapes.
INSET ABOVE: I used a No. 2 brush and an ultramarine and yellow ochre mix to join the stems between the leaves, and used an ultramarine and burnt sienna mix for the darkest parts, dampening the largest stem before applying paint.

7 For the centres I mixed new gamboge yellow and lemon yellow, and made up a mix of permanent rose and new gamboge yellow for the ends of the stamens. After wetting the centre with clean water and a No. 4 brush, I used a No. 2 brush to first apply new gamboge yellow, then used the yellow mix to produce a contoured effect.

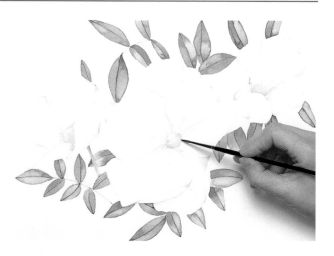

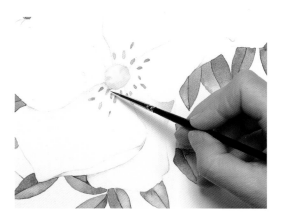

8 I dampened the areas of the stamens with a No. 2 brush, then dropped a permanent rose and new gamboge mixture onto it with a No. 0 brush. Even such a tiny area shows variations and has lighter and darker areas, so I used permanent rose on the stamen ends and went very carefully over the stamens again with the various yellows to finish.

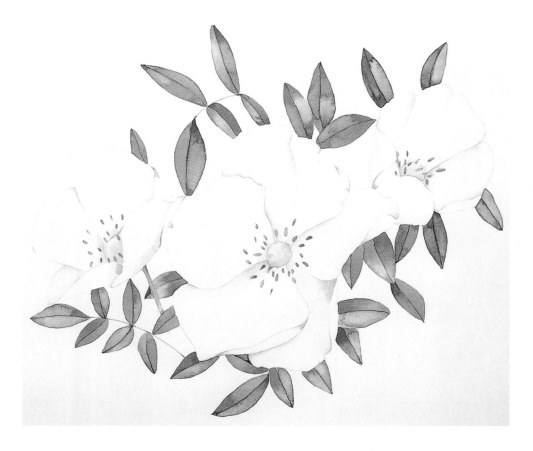

Detailed Work

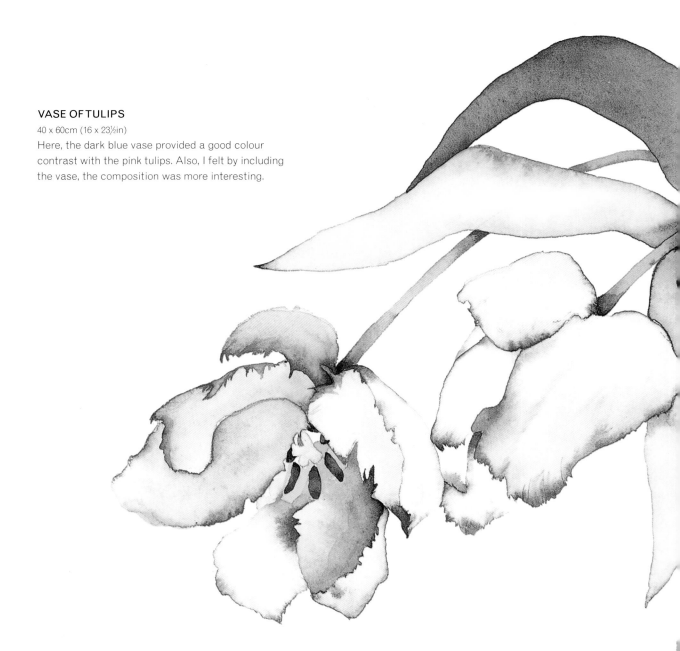

VASE OF TULIPS

40 x 60cm (16 x 23½in)

Here, the dark blue vase provided a good colour contrast with the pink tulips. Also, I felt by including the vase, the composition was more interesting.

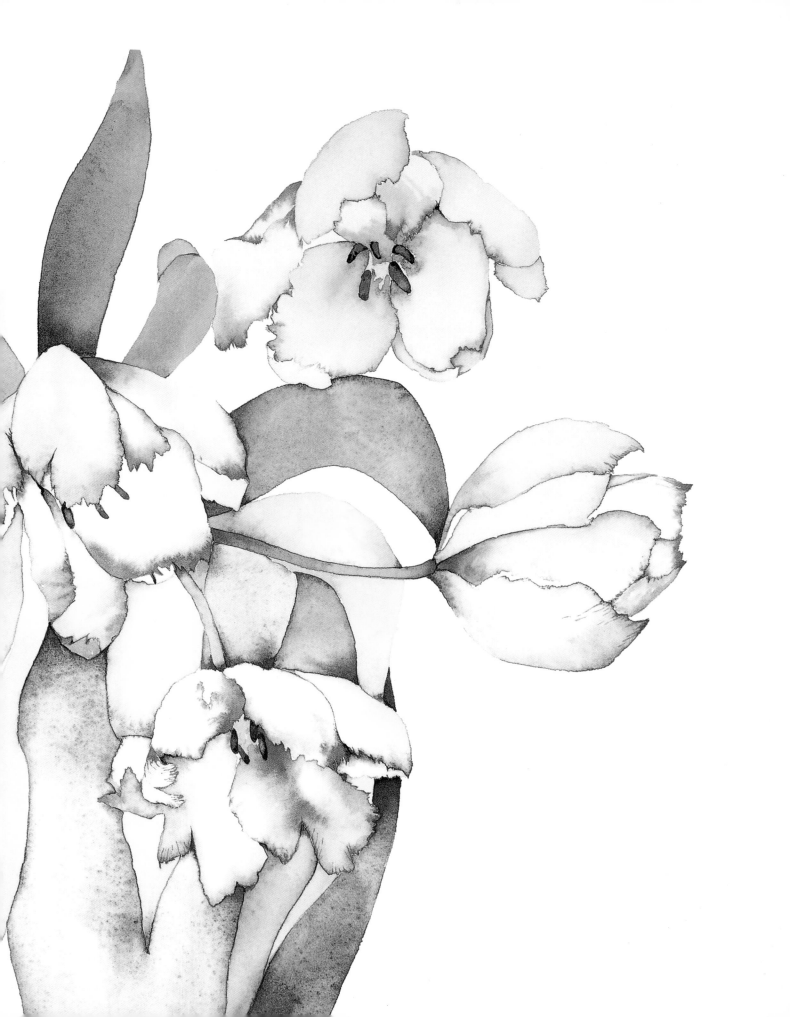

Flower details

My personal view on detail is that if it adds something to the picture, it's a good idea to include it, but if it's more like 'decoration', it may not be necessary.

In my flower painting I prefer not to add every vein, stripe and crease, apart from in vellum work, which lends itself to small brush work. But there are aspects of particular flowers that it is wise to include, as by excluding them some of the character of the plant may be lost. Good examples of this are the stamens and sepals on lilies or alstroemerias, the details on the face of a pansy, and the beards on an iris.

The main thing that must be stressed about detail is that it should be added last. On a recent painting workshop I explained this point, only to find someone gaily painting some 'spots' onto the petals within about the first 15 minutes. The trouble with this is that later on, if you find that your petal is too pale or you haven't added your shadows and then have to paint on top, this can muddy or spoil your detail.

In addition, there is something beneficial about learning to paint in a particular order – it teaches you discipline, which is a good thing with watercolour, and then you get into good painting habits. Doing so, in turn, slows down those of us who are prone to being impatient! This whole process can be likened to cake decoration – you wouldn't dream of adding delicate icing work before completely covering the cake with marzipan and icing.

Another point about detail is to always keep this work very delicate. It's so important to choose the correct-sized brush and use it properly – for example, when painting the small markings on a lily, use a small brush, such as a No. 0 with a good point, and paint with the point.

If you have taken a lot of trouble to observe the colours in your plant, do the same with the detail. Have a good look at the beards on your iris and ask yourself how many yellows there are – using one yellow would flatten this part of the painting.

Last, it's important to observe the details meticulously before you paint them. It's easy to make generalizations and end up with every dot or stripe exactly the same size and width, which is not only untrue to life but also flattens the flower. Our natural tendency is to neaten everything up – but just check those stripes before you commit paint to paper. You will find it useful to practise the detail on a piece of scrap paper before launching into the actual painting.

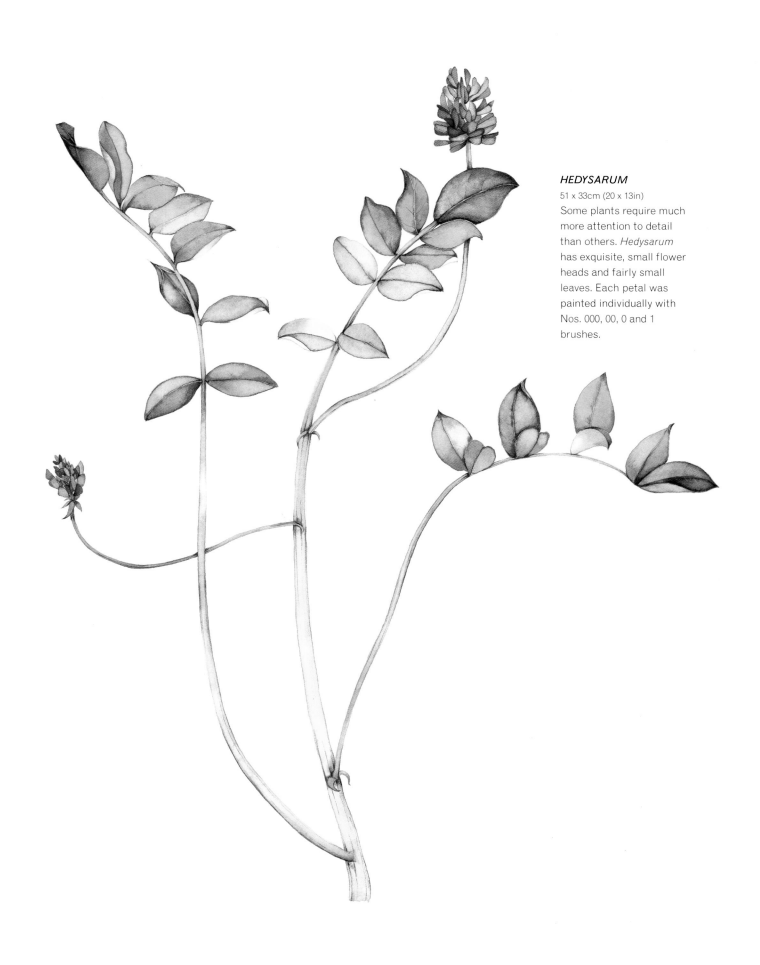

HEDYSARUM

51 x 33cm (20 x 13in)
Some plants require much
more attention to detail
than others. *Hedysarum*
has exquisite, small flower
heads and fairly small
leaves. Each petal was
painted individually with
Nos. 000, 00, 0 and 1
brushes.

Working on vellum

The first time I saw a botanical painting on vellum I felt totally in awe, and I clearly remember thinking that I would never be able to do anything like that. I was caught up by the mystique of painting on vellum and amazed at the sheer glow of the colours.

Colour always appears much brighter on vellum than on any paper you can ever work on, even though some papers are almost 'pure' white and vellum is often cream or even beige. The advantage vellum has is that the flower, leaf or fruit you have painted will look almost three-dimensional – as if you could pick it off the page.

Painting on vellum can prove quite a challenge if you are used to painting in a very wet and free style that is totally inappropriate for this medium. I started out trying to do a clever wet-in-wet technique that didn't work, as the paint just sat stubbornly where it was and didn't behave in the way I was used to on my watercolour paper. In the end, working in a much drier way with tiny 000 brushes proved a refreshing change from wet-in-wet. (I thought I was using the smallest brushes available until someone who came to one of my vellum painting workshops presented me with a 0000000000; I had to check it to see if it had one hair or two!)

Preparation

Either side of a piece of vellum can be used for painting, so as such there isn't a 'wrong side' and a 'right side', as when vellum is used in a book or manuscript it is worked on both sides. The better side to work on is probably the flesh side, as the hair side can be more rough and uneven.

The preparation of vellum can take a long time, depending on the method you use. Because the material is skin it must be carefully stretched and treated before you use it. This is absolutely essential, as vellum is highly sensitive to atmospheric conditions and will literally shrink before your eyes in the heat. I once hung a vellum painting above a radiator and the bottom of the painting shrunk out of its mount, revealing some unsightly writing that had been hidden under the mount in cooler conditions!

Preparing larger pieces
Pieces of around 48.5 x 63.5cm (19 x 25in) in size need to be tightly stretched over a wooden frame and stapled at the back to ensure a taut surface. This is similar to stretching canvas for oil or acrylic painting.

Preparing smaller pieces – quick method
Average small pieces of around 15 x 10cm (6 x 4in) can be taped to a board using masking tape; take care to pull the surface completely flat.

Preparing small or medium pieces – longer method
Small or medium pieces can be mounted onto stiff card or thin board using flour and water

paste, which should be the consistency of single cream without any lumps.

Apply the paste to the board and smooth the vellum on to it using a small roller, such as a printing roller, to flatten the piece and remove any air pockets. Clean off any excess glue from around the edge of the vellum, ensuring there is none on the surface.

Place a protective piece of paper over the top of the vellum, then place the vellum under some heavy weights, like a big pile of books, or inside a press if you have one. It will take a day or so for the vellum to dry, and it can't be used until it has completely dried out.

Pouncing the vellum

To ensure that the surface of the vellum is perfect to work on, it must be pounced. The fine powder called pounce is made up of French chalk and pumice powder.

It is absolutely essential to pounce your vellum, which will remove any grease or irregularities from the surface before you begin painting. If you don't pounce the vellum, the surface is likely to be extremely greasy, which repels water making it almost impossible to apply paint.

TAKE CARE OF YOUR HANDS!
Pounce can be quite abrasive, so take care not to skin your fingers. You can use very fine abrasive paper, but only on the very thickest pieces of vellum – if in doubt, don't.

1 Tape down the vellum onto the drawing board, then put a pile of pounce in the centre – for a piece 15 x 10cm (6 x 4in) use a pile about 3.8cm (1½in) in diameter, but too much is better than too little.

2 Use one or two clean fingers to rub the pounce into the vellum, starting at the top and rubbing quite hard in small circular movements to remove grease from the surface. Rub for about five minutes for a piece this size. At the end, the vellum may feel smoother to the touch, but not necessarily so.

3 After removing only the top amount of pounce with your hand, use a clean soft brush to wipe the rest off the surface back into its container, avoiding getting grease from your hands back onto the vellum (pounce can be reused). Blow the pounce off while brushing to ensure the surface is clean.

PROJECT: PAINTING ON VELLUM

I am fascinated by all bulbs, and the small onion here is my favourite of all the subjects I have painted on vellum. It gives you the opportunity to study something in close up, and still to be surprised at how complex and colourful it is.

The onion skin is made up of sections that provide small areas to be concentrated on; these can help to stop you from feeling overwhelmed by your subject. These sections, and the onion's texture, are ideal for the fine brushwork required when working on vellum. I used the highlights to enhance the onion's three-dimensional quality, and when I finished the painting I was amazed at how bright and colourful it was, despite using a fairly limited palette of colours.

2 Working away from the vellum, I used a soft graphite stick to draw the onion shape on the reverse of the layout paper, concentrating on covering all the lines with small strokes. I lifted the paper up regularly to check that I hadn't missed any lines.

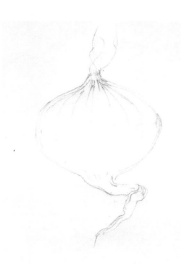

1 I drew the onion onto layout paper with a 4H pencil – an alternative is to use tracing paper, but the method shown here enables you to work more loosely and freely.

3 I used a folded piece of clean tissue paper to polish the graphite marks, again working in small circular movements. This not only got rid of spare surface dust and smoothes the surface, but also meant that I could use the drawing more than once.

4 Having taken the time to position the layout paper 'right side up' on the vellum, I taped it firmly in place on one side only, so that I could lift it up to check on my progress. I then used a sharp 4H pencil to redraw the onion, this time through the graphite onto the vellum, with a fair amount of pressure, checking regularly.

5 I sometimes used the pencil to reinforce the marks.

6 I made up some very watery mixes in preparation before actually starting to paint the lighter side, using a No. 4 brush to make small strokes of a burnt sienna and ultramarine mix. Switching to a No. 2 brush, I continued, using a stronger mix, which was still very watery, and leaving the vellum untouched in the highlight areas.

Tip
Keep the layers of paint very light at the start, even though they sit on the surface, unlike water-colour paper.

7 I alternated between the brushes to build up the colour and introduce a more yellow mix of yellow ochre and new gamboge yellow, then added a mix of burnt sienna and Indian red – this was to add interest to the subject and to bring out a colour that was there, even though it might be faint or small.

Tip
Be careful not to overwork paint on vellum, as it can be lifted off the surface, even when dry.

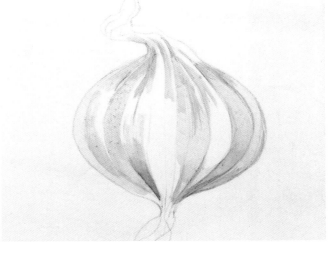

Project: Painting on Vellum

8 I made a greyish-brown mix from burnt umber and ultramarine for the shadow at the base of the onion, which helped to place it in relation to the surface on which it sat; this colour could also be seen on the body of the onion, so I added it to those places. It is a good idea to squint through half-closed eyes to set the darkest areas; I picked the onion and held it close to the same-size painting to fix the details in my mind.

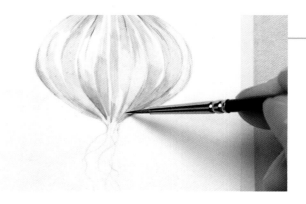

Tip

When working in this much detail, make sure you take regular breaks so that your eyes can focus normally for a while. Some paintings on vellum can take days or weeks because of this.

9 I darkened the already worked-on areas, using the same mixes but a little stronger each time. I used a No. 2 brush for the top part of the onion, noting that even this has as much variety as the main body, and went right down in size to a No. 000 brush for the thinnest parts.

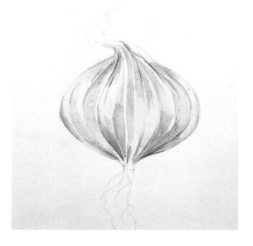

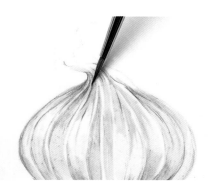

10 I now built up the top, following the contours and establishing the colours and layers, and moving through the mixes and brushes. After drawing in the tiny dark veins to show their form, I used a dark mix of burnt sienna, ultramarine and Winsor violet on the darkest shadows and folds, and then brought this up into the main body.

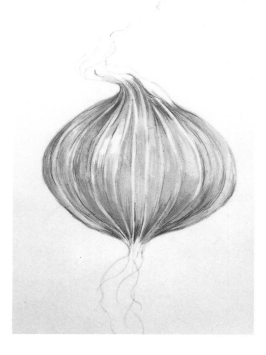

11 At this stage I began to cover up the 'white' areas of unpainted vellum, and added brighter versions of the yellows and reds across the onion – all the time using small strokes that followed the contours to show its roundness. The magnifying glass came in useful here, to help me get as much information on my subject as possible before adding any further layers of paint (see page 21).

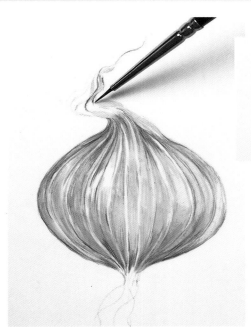

13 To make a grey for the 'beard' at the bottom of the onion I mixed ultramarine, burnt sienna and Winsor violet, and applied it using a No. 0000000000 brush – I worked very lightly, just to suggest the tiny hairs, which were matched by the size of the brush itself.

12 Now I used the magnifying glass to see the finest details on the top part, which I painted using a No. 000 brush. I was still concerned about making the darkest areas dark enough, so strengthened the mixes slightly.

14 I wanted some brighter highlights, so I decided to lift off some paint – this doesn't remove all the layers, but lightens them. I put a little clean water on a 1/8 acrylic brush and moved this two or three times on the paint, cleaned the brush on clean tissue and lifted off the paint. I stopped before there was any danger of overworking this part.

Tip
Lifting off is useful for cleaning small blobs and stray bits of paint from vellum, and can also be used carefully on watercolour paper.

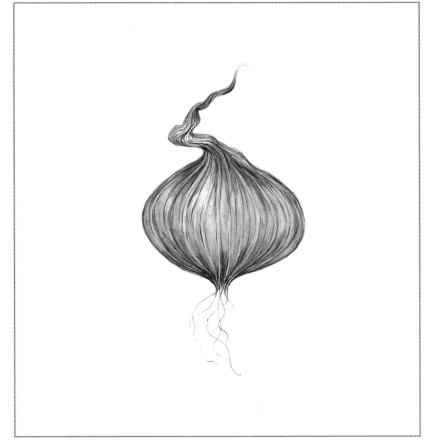

Vellum gallery

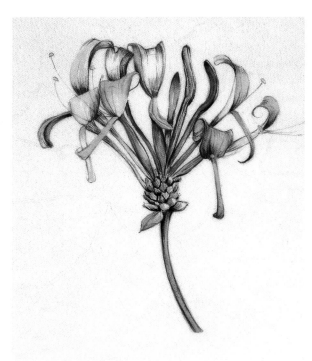

HONEYSUCKLE

12 x 10cm (4¾ x 4in)

The fine detail and wealth of colour in a honeysuckle shows up extremely well when painted on vellum – this is much more vibrant than if it had been painted on watercolour paper. This was painted with very small brushes, Nos. 2 to 000.

MARTAGON LILY SEED HEADS

14 x 10cm (5½ x 4in)

The seed heads were painted mainly using a stippling method and a 00 brush with a very fine point. Care must be taken not to paint over any 'highlights' – although you can lift paint from vellum; you can never get back to the original clean surface.

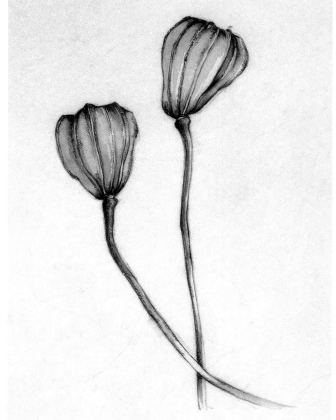

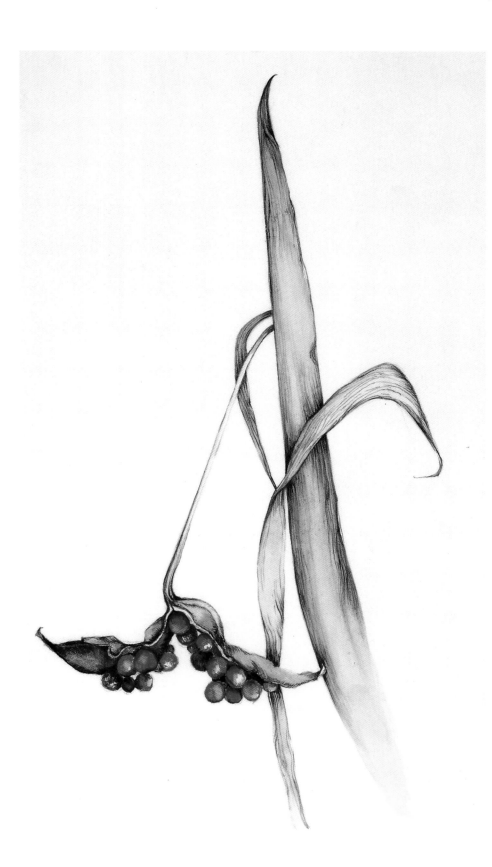

IRIS FOETIDISSIMA
20 x 13cm (8 x 5⅛in)
This took several
weeks to paint, as
working so finely can
tire your eyes – it's
essential to take plenty
of breaks and not
overdo it. By taking my
time I was also able to
consider what the
piece of work needed
stage by stage.

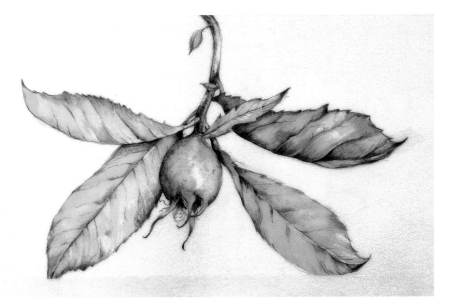

AUTUMN PIECE
10 x 14cm (4 x 5½in)
Autumn fruits, hips and berries are good to paint on vellum, as you can enhance the shiny highlights easily by lifting off.

WHITE ROSE
9 x 6cm (3½ x 2½in)
This was painted using the same observation discussed in the chapter on 'White Flowers', where you need to look for the reflected colour and shadows to create the form of the flower (see page 77).

TULIP TREE FLOWER SEED HEAD
13 x 12cm (5⅛ x 4¾in)
The gnarled, woody stem on this seed head is ideal for fine dry brush work on vellum. The seed head was painted in a similar way to the project on page 92 – painting section by section.

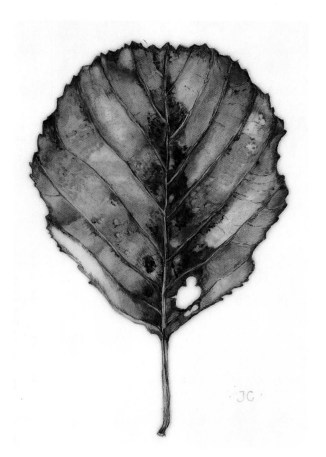

LEAF

14 x 9cm (5½ x 3½in)

I enjoyed painting this more than any other vellum study. I used a magnifying glass to observe the colours and minute markings on the decaying leaf.

TULIP TREE FLOWER

14 x 11cm (5½ x 4⅜in)

This was painted by using slightly larger brushstrokes than, say, the tulip tree flower seed head opposite, because of the nature of the petals. The colour and markings depicted here are particularly true to life.

An Impression of a Flower

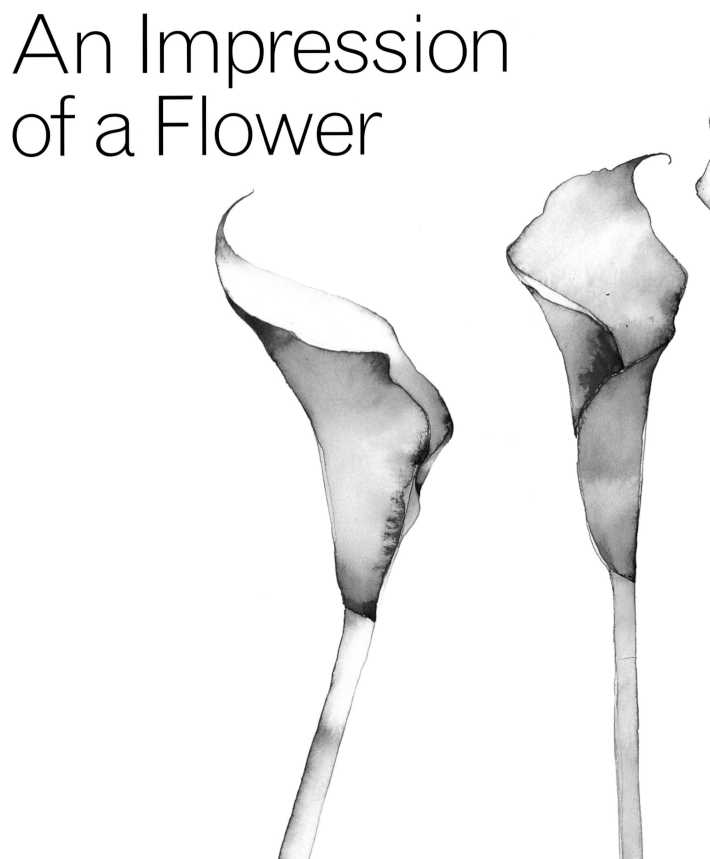

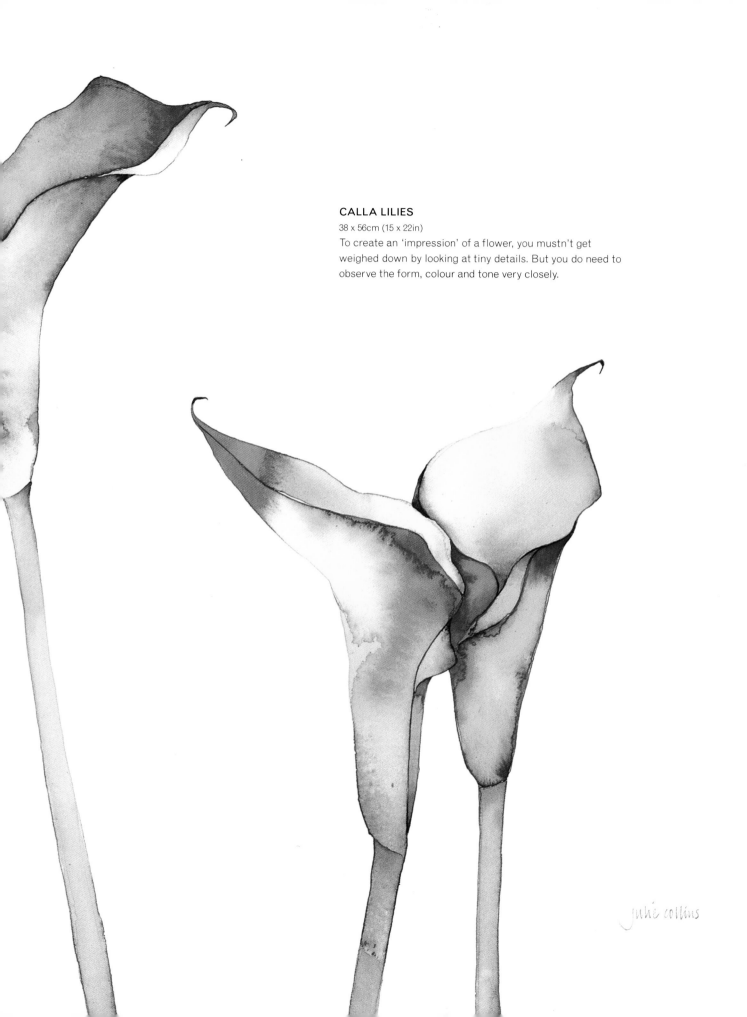

CALLA LILIES

38 x 56cm (15 x 22in)

To create an 'impression' of a flower, you mustn't get weighed down by looking at tiny details. But you do need to observe the form, colour and tone very closely.

julie collins

Looking for inspiration

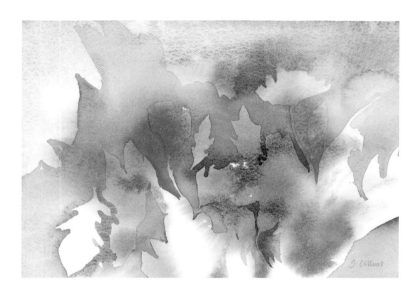

IMPRESSION OF FLOWERS

13 x 20cm (5⅛ x 8in)
I remember thoroughly enjoying doing this painting, as I felt able to interpret the subject in a free and creative way and wasn't concerned about representing the flowers as they were in real life at all.

Opposite:
FUCHSIA

25 x 19cm (10x 7½in)
By painting this flower much larger than life I was able to go to town with the paint on the petals and also create a slightly abstract piece.

Planning the step-by-step project for this section (see overleaf) caused me an inordinate amount of grief. Possibly I'd been trying too hard to come up with the most amazing, complicated composition, but I experimented with all sorts of flowers, arranged in every way I could think of. Although this produced some good paintings, I didn't feel anything was suitable for a project called 'Exploring colour'.

My other problem was that I felt spoilt for choice, and instead of doing one painting I wanted to paint all the flowers I loved in various combinations – which would then have taken us to Volume Ten in an ever-continuing series!

Taking the lateral view

The night before I finally decided what to do, I went to a short talk by a professional photographer, who showed some very inspiring slides of work by her favourite photographers, including several of her own shots. She was very interested in taking photographs of gardens in an unconventional way – where, for example, there was an arrangement of chairs on the lawn but no people in the picture, as if we, the viewers, had missed something that had just happened. All the pictures were taken through a hedge or round a tree, as if she were spying on her subject, but this also framed the picture nicely.

It made sense to relate to this approach – where each flower is placed in paintings is very important, and in my better work I have spent a great deal of time thinking about it. The morning after the photographic talk I could see what I wanted to do and realized that my work is about exploring colour anyway, so I should stop worrying about which flowers to include and get on with creating a decent composition to explore colour.

When I'd finished the piece and painted the pure colours I had used as swatches, I was surprised at how few colours I'd actually used – because the painting took a long time to complete, I was convinced I'd used nearly all the colours in my palette. So, with a limited palette and plenty of mixing you can produce a very colourful picture.

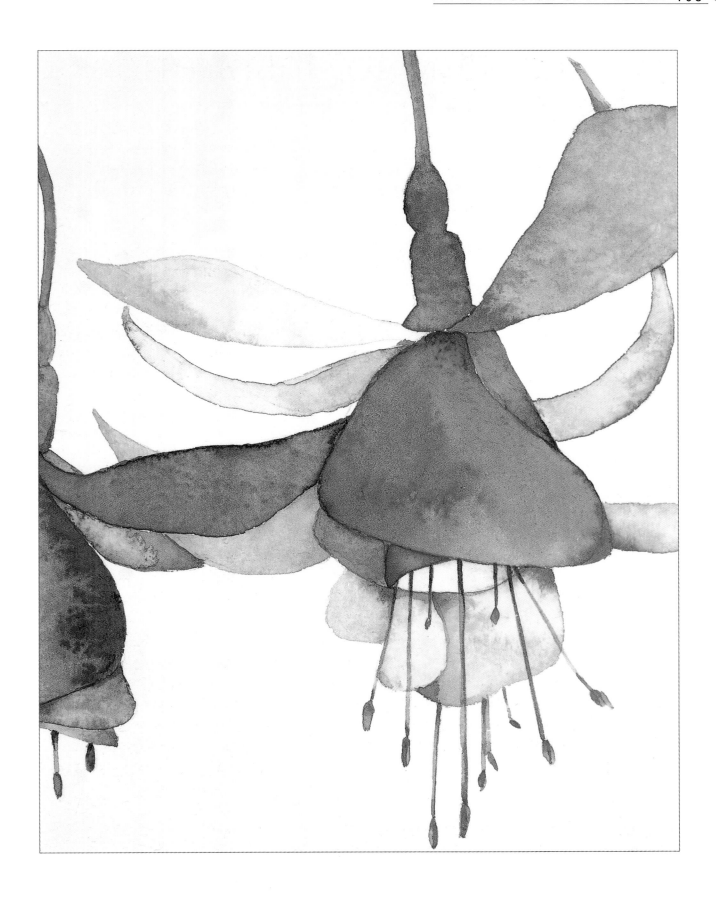

PROJECT: EXPLORING COLOUR

MATERIALS

Pencils
4H pencil

Watercolour

Winsor violet

Cobalt blue

Alizarin crimson

Ultramarine

New gamboge yellow

Burnt sienna

Hooker's green

Winsor green (yellow shade)

Lemon yellow

Winsor red

Quinacridone red

Brushes
Nos. 4, 0 round
Isabey 2/0 mop

Paper
Saunders Waterford HP
320gsm (160lb)

Additional equipment
Kneaded putty eraser

For this project, my planning started with deciding to include irises: these have such interesting structure and form, and are always very popular, and their particular shapes work well in mixed flower compositions. To complement their complex structure, I chose tulips, which have a more simple shape and are available in many colours. The *Alstroemeria* wasn't chosen for its flowers, but for the leaves, which have a fantastic structure to paint and draw.

Last, I planned the colours. The irises had to be deep violet, and I knew I wanted to include warm pink and hot red to complement the wide variety of greens in the leaves of each flower.

1 This is quite a large picture at 50 x 38cm (19¹/₂ x 15in), and even though there is a lot going on in it, I was careful to try to avoid a cluttered atmosphere. I made the initial drawing in 4H pencil, which I enhanced with thicker lines so it would show up in the photograph here, and subsequently erased back to its original strength.

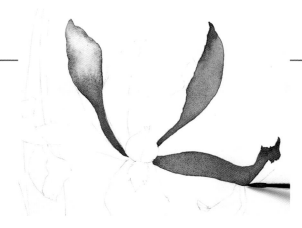

2 For the iris petals I made two mixes of Winsor violet, one medium-strength and the other darker, and added a bit of cobalt blue to both of them. The next mix, of Winsor violet and alizarin crimson with a touch of ultramarine, was darker than the first two, and a mix of alizarin crimson and ultramarine, was darker still. Using the Isabey 2/0 mop brush, I applied the medium wash very wet onto non-adjoining petals, allowed the washes to dry a little, and then added combinations of the darker washes with the No. 4 brush.

3 Working across the whole composition, I blocked in similar parts of the sets of petals, checking each petal for variations of light, shade and tone, and diluting and changing the washes as appropriate; there were also variations with each set of petals and within the whole group. I used the very tip of the No. 0 brush for the tiny patches of colour.

Tip
Always test each wash on a piece of scrap paper of the same type as you use for the painting – even straight, unmixed colours may not come out as you assume they will!

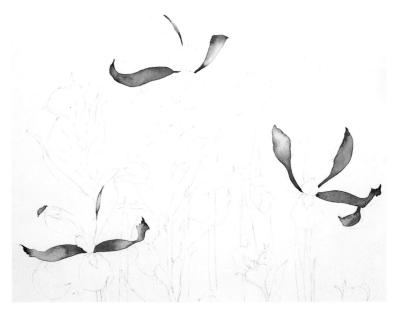

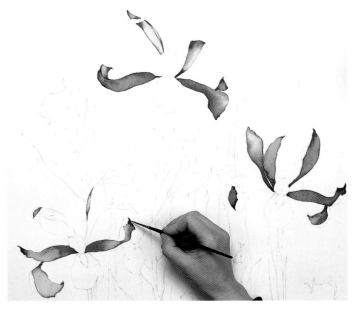

4 As I added more of the petals, I kept a sharp eye on the patterns that were developing across the composition, even at this stage. For the innermost edges of some (but not all) of the petals I made up a very dark mix of Winsor violet, new gamboge yellow and ultramarine, and applied this with the No. 0 brush, dabbing excess water and pigment off with a piece of kitchen roll where necessary.

Project: Exploring Colour

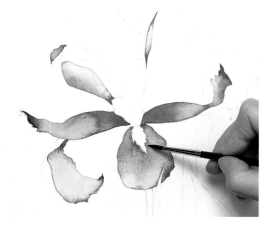

5 As each set of petals dried completely, I took time out to assess my progress and check that the painting was how I wanted, then I added more colour where needed, as well as applying new washes. On the dry petals, I began to add some detail, painting into the negative spaces of the 'beard' in the middle of the flower with the No. 0 brush.

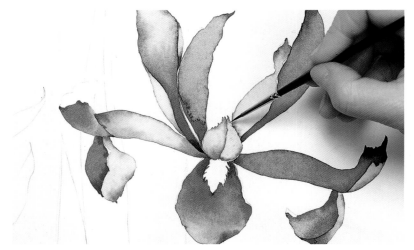

6 When each set of petals was completely dry, I added the folded-over tips and folds and creases, being aware that these applications were extremely unlikely to be the same tone or shade as what was already there. Even at this early stage, the washes had moved on quite a bit from the original mixes I had made. As each new part dried, I checked it against the other parts of the flower and made adjustments as required.

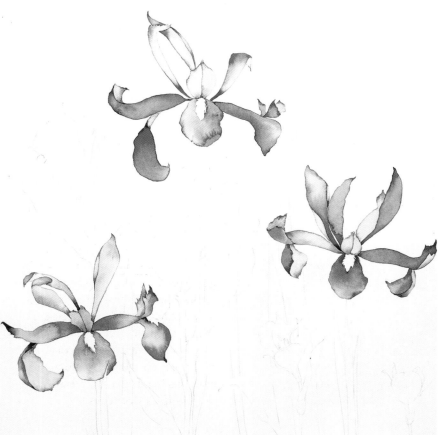

7 The patterns and shapes of the petals were now beginning to fill in the composition, but I wasn't in a hurry to finish any particular area yet, concentrating on the strengths and colours of the mixes instead. I left the places where leaves or stems went across the petals as negative spaces, working from the darkest petals and darkening some of the lightest ones for unity in the colour spectrum.

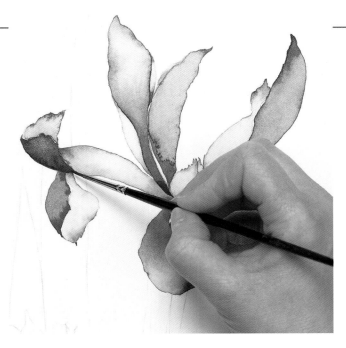

8 With the shapes of the petals in place, I used the No. 0 brush to add the small dark areas and details across the painting, and then switched to the larger round brushes for the larger darks and shadowed areas. I allowed all the washes to dry thoroughly.

9 For the petals of the Peruvian lilies (*Alstroemeria*) I made a series of washes: one medium and one watery straight alizarin crimson; alizarin crimson and less burnt sienna; and two mixes of alizarin crimson and ultramarine, one medium-strength, the other very dark. Having decided not to paint the usual spots on the petals, I started by applying pale washes with the No. 4 brush, then added the darkest reds while the pale colours were still wet with the No. 0, letting the darkest parts sink to the bottom of the petals.

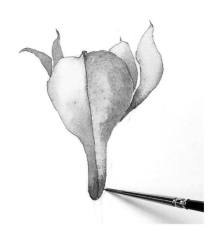

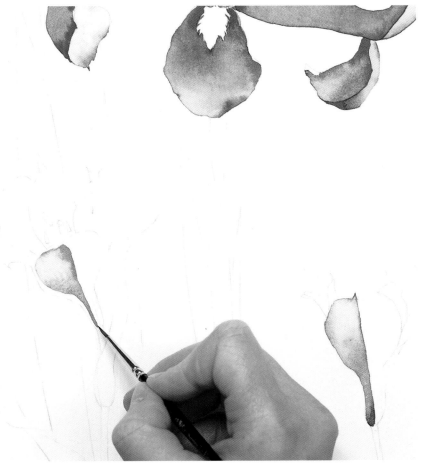

10 As before, I worked on one side of each petal at a time – this also had the effect of suggesting stripes when I painted the other 'half'. I applied all the colours, both pale and dark, quite wet, so the paint could make the differences in tone, and was careful not to use too bright a selection of reds, keeping them cool to match the purples of the dry petals.

Project: Exploring Colour

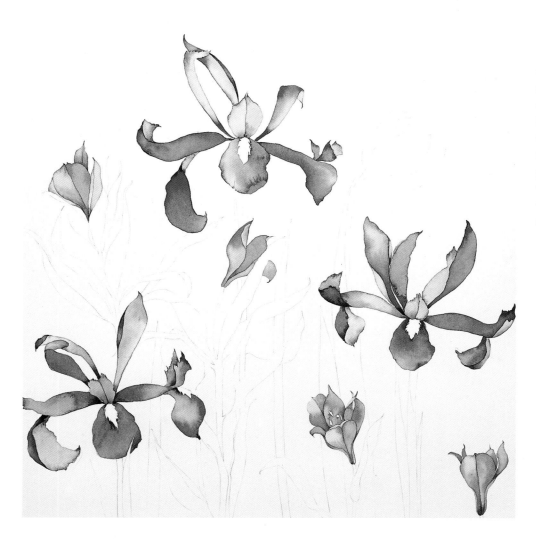

11 I continued to work on the red petals across the composition, painting around the negative shapes of the stamens with the No. 0 brush, and checking on the similarities and differences between each group of petals and as a whole. When I was satisfied with the group so far, I let all the washes dry.

12 To darken the iris petals I made up stronger new washes of ultramarine and cobalt blue, Winsor violet and ultramarine, Winsor violet and alizarin crimson, and ultramarine and new gamboge yellow. I dampened some – but not all – of the dry pigment on the petals with clean water, leaving about 20 per cent of the original washes showing through on the dampened petals, and dropped combinations of the new darker washes into the water to darken the petals.

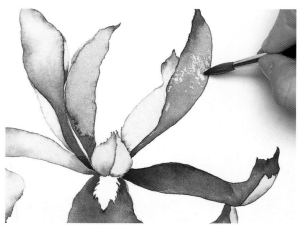

Tip
Applying clean water to dried washes and then dropping in new mixes takes some practice and time, but the effects are well worth persevering with on scrap paper.

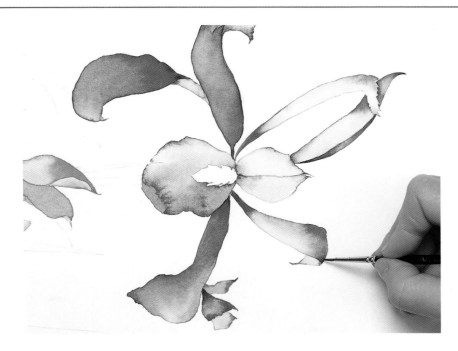

13 When the first red washes had dried, I looked over the whole painting, checking on the tone of each petal that touched another one. Working on alternate petals, I dampened each one from the centre or where it touched another, then dropped in a dark wash and pulled the paint out along the length of the petal.

Tip
On a painting of this size, turn the paper round to make it easy to reach each part – trying to work from just the same angle would make life very difficult, and would detract from your concentration.

14 Next, I mixed the greens for the *Alstroemeria* leaves and stems: Hooker's green with a touch of alizarin crimson; a dark mix of Hooker's green with less Winsor violet; two mixes of new gamboge yellow and ultramarine, one with about equal amounts and the other with more yellow; and alizarin crimson and Winsor violet for the touches of red on the stems. I applied a watery wash of the green/violet mix onto dry paper, and then strengthened the colours while they were still wet. Where they met the stems, I took care to paint the leaves lightly.

Tip
Leaves are rarely uniform in colour or texture, so use as many mixes and dilutions as you need to produce an effective result.

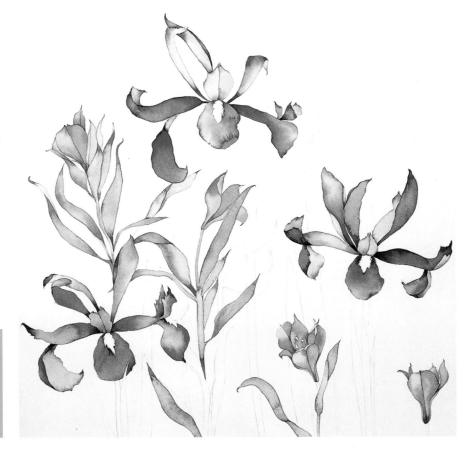

Project: Exploring Colour

15 As I painted, I was careful to check the relationship between the greens I was applying and the purples and reds of the petals. When the first stem and leaf washes had dried, I mixed stronger versions of the green colours, plus a new wash of ultramarine, new gamboge yellow and alizarin crimson. I then used the same method of wetting dry pigment with clean water and dropping in pigment as for the petals.

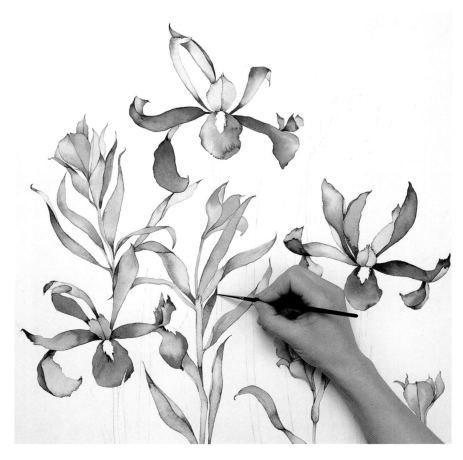

16 For the iris stems and leaves I mixed new washes: two of ultramarine and new gamboge yellow, one with more yellow; two of Winsor green (yellow shade) and burnt sienna, one quite watery; and one of equal amounts of Winsor green (yellow shade) and new gamboge yellow. I started with very wet initial washes, working dark to contrast with the irises and using the point of the Isabey mop brush to work in the direction of the stems, and switched to the No. 0 for where the stems go in front of, or behind, other parts of flowers.

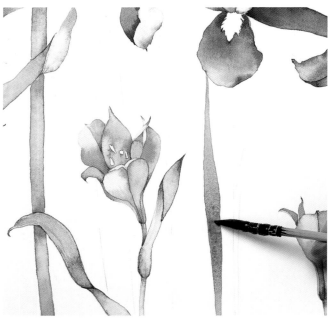

Tip
Dont forget that the washes shown here are a guide; you can follow them to get yourself started, but once you look hard at the flowers you are painting, you will undoubtedly see and use different colours and tones.

17 I made a mix of lemon yellow and less ultramarine for the tulip stems, as this bright colour would contrast well with the darker greens of the other flowers. While the first washes were still wet, I dropped in a darker version for the shadow areas. On standing back and looking at the composition, I added another tulip leaf above the top right iris head, both for balance and to bring the flower more into the composition; I still had to be very careful not to clutter the overall feel of the picture.

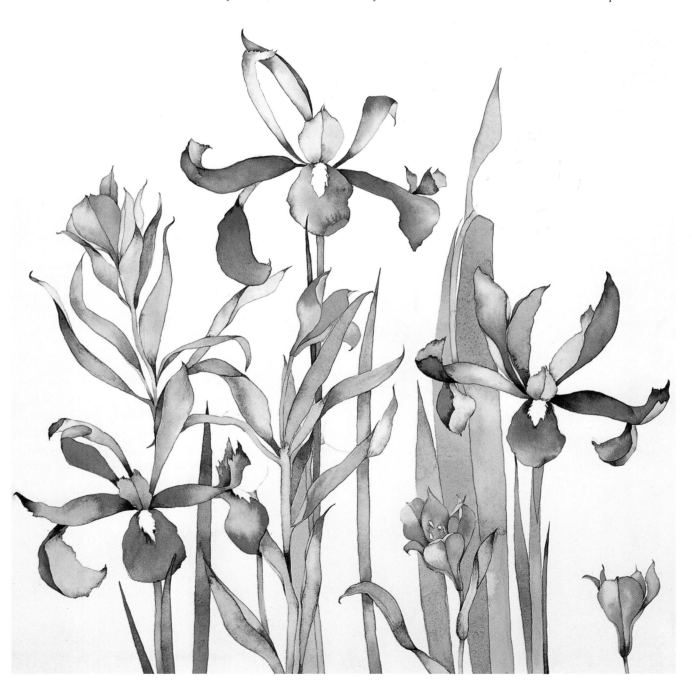

Project: Exploring Colour

18 As the tulip leaves and stems dried, I added the darks and shadow areas, blending the colours gently and modifying other stems and leaves as necessary. For the tulip heads I made washes of straight Winsor red and quinacridone red, and then made a mix of the two reds. After applying a wash of clean water to the petals I dropped in the colour, making sure not to cover the whole area and moving the pigment around with the No. 0 brush. Inset right: While the tulip heads were drying, I mixed new gamboge yellow and lemon yellow for the centre of the iris 'beards' and, while this was still wet, applied straight new gamboge yellow for the area around the edge where it met the purple. I made a black from alizarin crimson, Hooker's green and ultramarine, then dropped this into the dampened areas of the stamens.

Tip
Make sure you clean your palette thoroughly before mixing yellows or making yellow washes – even the smallest traces of another colour can dull or dirty yellows.

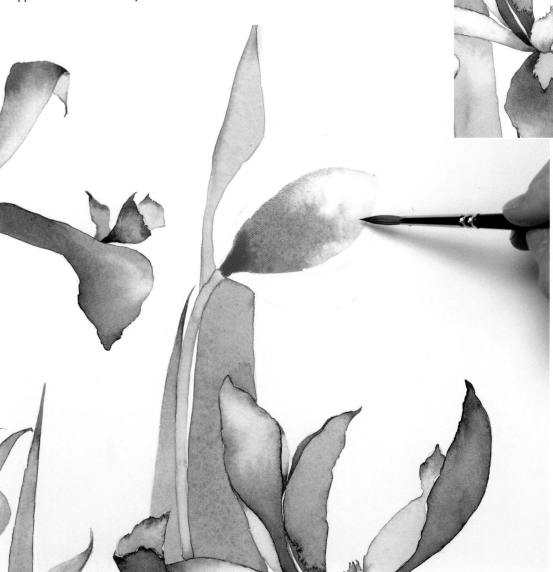

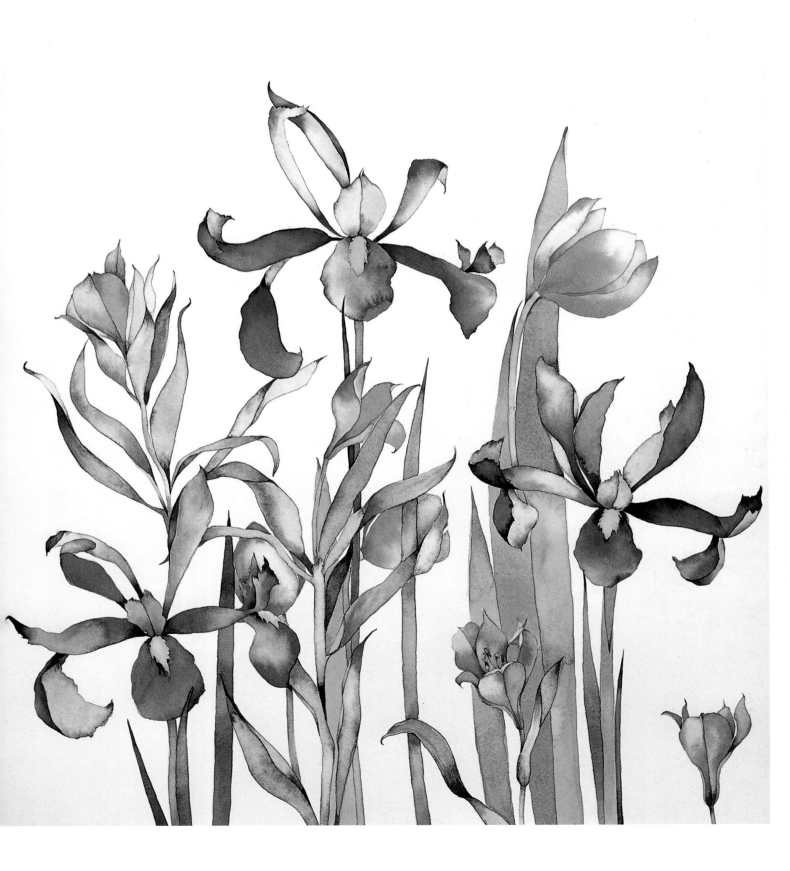

Towards abstract

ARRANGEMENT OF FLOWERS

18 x 26cm (7⅛ x 10¼in)
I painted this piece using a less formal method, working between the flowers and the background in no particular order, although I added the 'darks' last.

**Opposite:
BULB**

56 x 38cm (22 x 15in)
This bulb is painted larger than life. Here, I took a more creative approach, abstracting from reality to explore colour and composition.

Moving further away from reality and becoming more abstract may be the next natural step to take in your work. This is a very personal decision, which certainly wouldn't suit everyone, but if you have reached this point in your work, don't be afraid of progressing. The more experienced you become at painting watercolours, the more you will feel confident about what to leave in and what to leave out of your work. Your paintings may become 'understated' and more 'abstracted'.

Abstract doesn't have to mean a painting made up of circles and squares – it could simply mean that your paintings will contain far less detail or become an 'impression' of your subject. Working in a freer style opens the door to experimentation, and from experience this is both incredibly exciting and frightening.

Whenever I have developed my work I've gone through a period of experimenting and making plenty of mistakes. Sometimes this has been very difficult, but in retrospect it has always paid off.

To paint in this way you need to leave behind the idea of creating an exact representation of the flowers in front of you. This is much easier said than done if you are used to producing quite realistic work. But if that's how you feel you want to work, then persevere. During a two-day course, a lady painted some good studies of the pansies we were working from. At the very end of the second day she decided to paint without drawing. The results were terrific, as she produced lovely, understated watercolours that had the understanding of the flower without being an exact copy. It may be easier to reach this level by working in a formal way first, so that you have time to get to know your subject, and then, when you feel confident, launch off towards abstract.

If you are interested in working in this way then spend even more time considering how you might tackle your painting. Look at your subject even more closely and from various angles so that you give yourself plenty of time to digest ideas. To help, take some scrap paper or your sketchbook and start 'doodling' – letting your imagination go at the same time.

Everyone's interpretation of abstract will be different and so the best advice I can give is to experiment as much as possible.

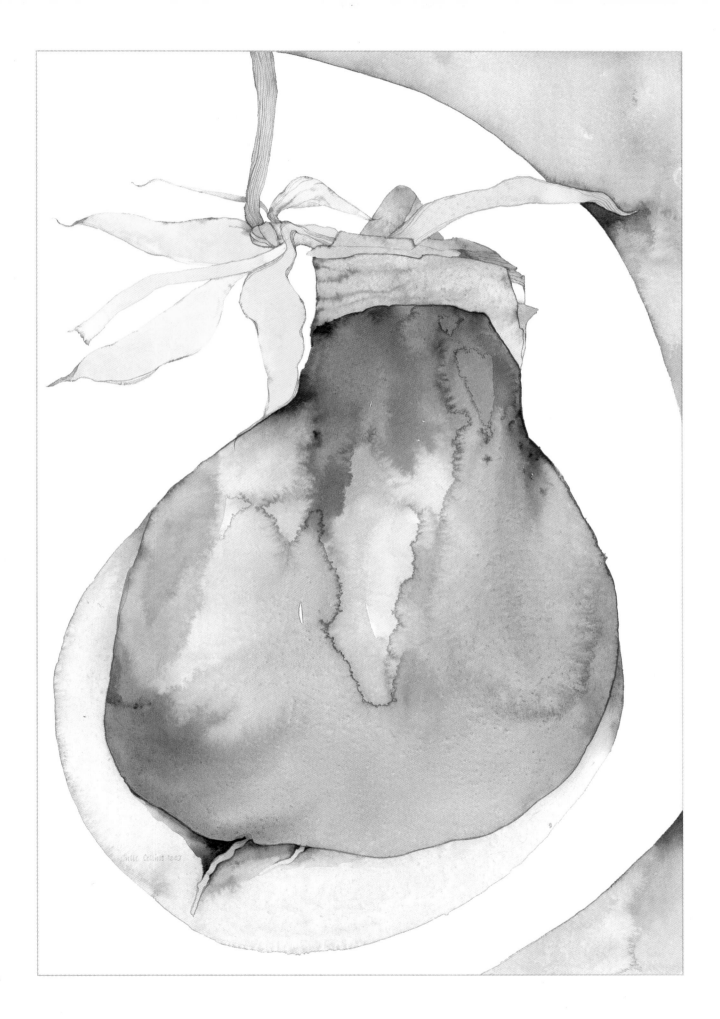

Gallery

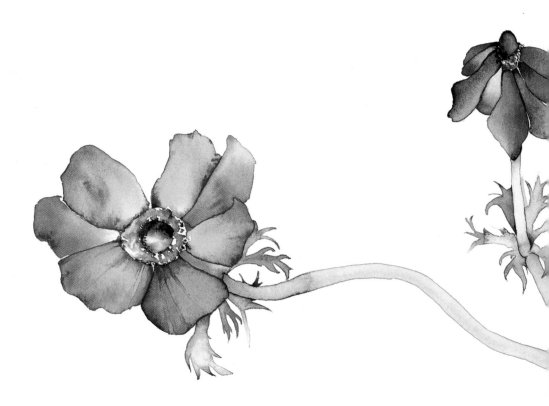

ANEMONES

66 x 102cm (26 x 40in)

Think about combining flowers with a pot, vase or in a still life to create a different style of flower painting.

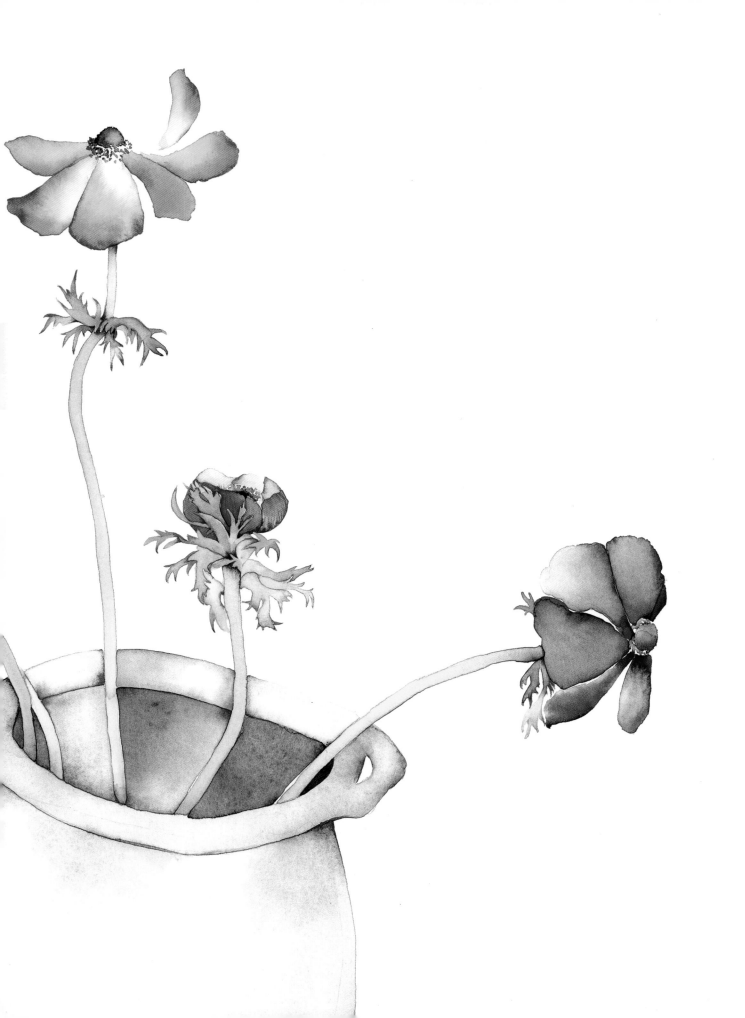

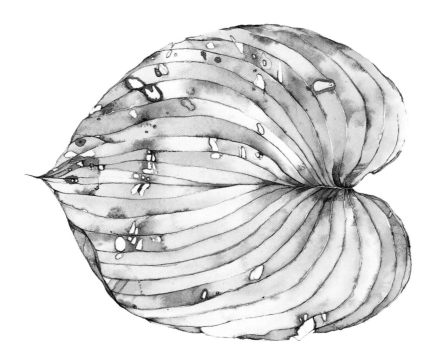

HOSTA LEAF

36 x 42cm (14 x 16½in)

The blemishes, holes and dried-up parts of this leaf are very attractive. The leaf was painted section by section – for the most part I allowed each section to dry and not run into one another.

POPPY HEAD

36 x 42cm (14 x 16½in) Sometimes it can be inspiring to paint a flower head much larger than life. Particular flowers lend themselves to this, and the method can give you plenty of scope to use a lot of paint and larger brushes.

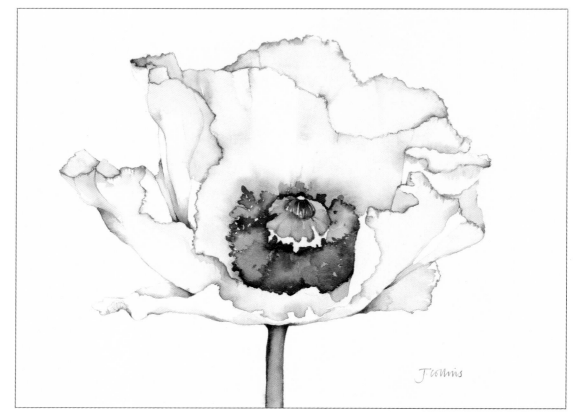

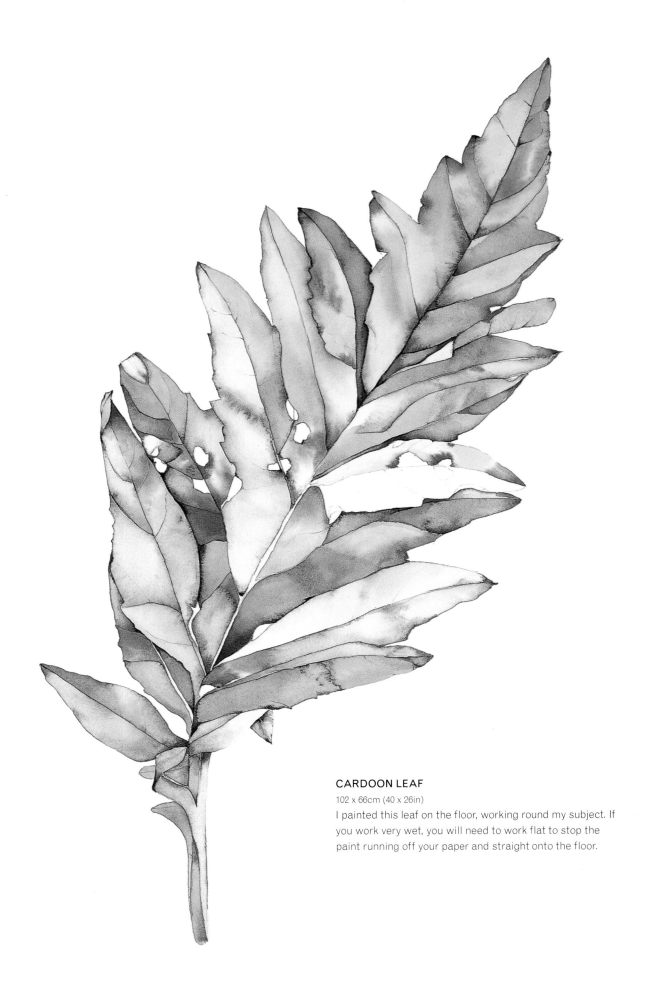

CARDOON LEAF

102 x 66cm (40 x 26in)

I painted this leaf on the floor, working round my subject. If you work very wet, you will need to work flat to stop the paint running off your paper and straight onto the floor.

GUZMANIA

38 x 56cm (15 x 22in)
This plant makes a
fairly complicated
composition and I had
to spend plenty of time
observing the form
before beginning work,
particularly in the
detail of the flower
head.

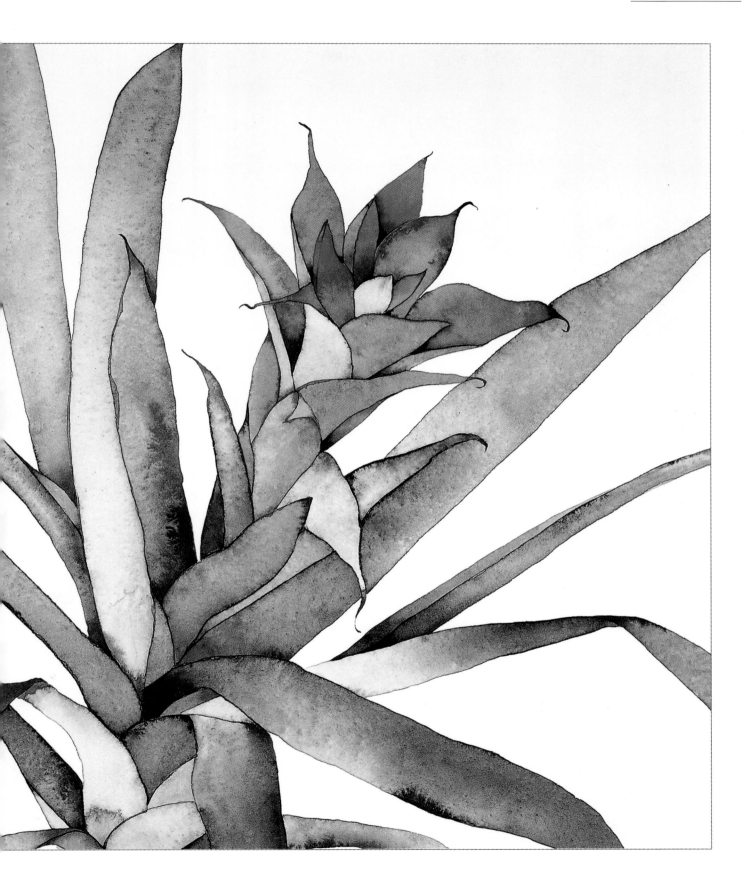

Failures and experiments

Opposite:
FREE FLOWER COMPOSITION
23 x 17cm (9 x 6¾in)
Here I used little, if any, drawing and allowed some of the colours to bleed into each other so there is not much definition.

A common myth about artists is that they never make any mistakes or experience any failure, and that every painting goes swimmingly. My advice on failures and experiments may sound as if I've got it all sewn up, but this is far from the truth.

I have made more messes, ripped up 'bad' pieces, overworked something that was going swimmingly and had more artist's block than you could ever imagine. On a good day I calmly tell myself that this is all part of the painting process; on a bad day I doubt myself as an artist and consider a new career, feeling far too uptight to do any decent work and having to confine myself to doing my accounts on my PC (my least favourite job of all)!

Too often people approach a painting with a set view of doing a 'good piece' rather than just putting brush to paper. When I teach, I advise students to just enjoy the painting and not to worry too much, but sometimes this is easier said than done.

At times there is no rhyme or reason as to why a particular painting has turned out very well; this usually happens when you least expect it. More than once people have come on a two-day course with me, done some good work and made progress, and then during the last 10 or 20 minutes they have produced a fantastic piece, always to their amazement. This often happens when you are in the swing of painting – in what I call the creative mode – and have relaxed into your work.

One way around having too many failures is to always have lots of paintings on the go at once. This has numerous benefits – it stops you being too precious about one piece, and also helps you stop fiddling and overworking, as you can always move on to another piece of work if you are tempted to overdo it. As with anything else in life, the more you paint the more likely you are to be successful.

I keep all my work in a large plan chest in my studio. Approximately every six months I have a grand clear-out – throwing out and enjoying ripping up some unsuccessful paintings. Some failures are kept as a reminder as to how much I have improved and learnt, and other pieces are kept because there are some good bits in them. After a grand clear-out I feel less cluttered and freer to paint.

At a recent watercolour course I used the other side of the paper of a 'failed' painting of a lily. One of my students was appalled – 'I'd have had that!' she exclaimed – but I had abandoned it because it wasn't good enough, and I had accepted it as a 'learning piece'. Don't be afraid of experimenting or failing, as these experiences can be when you learn the most and move on furthest.

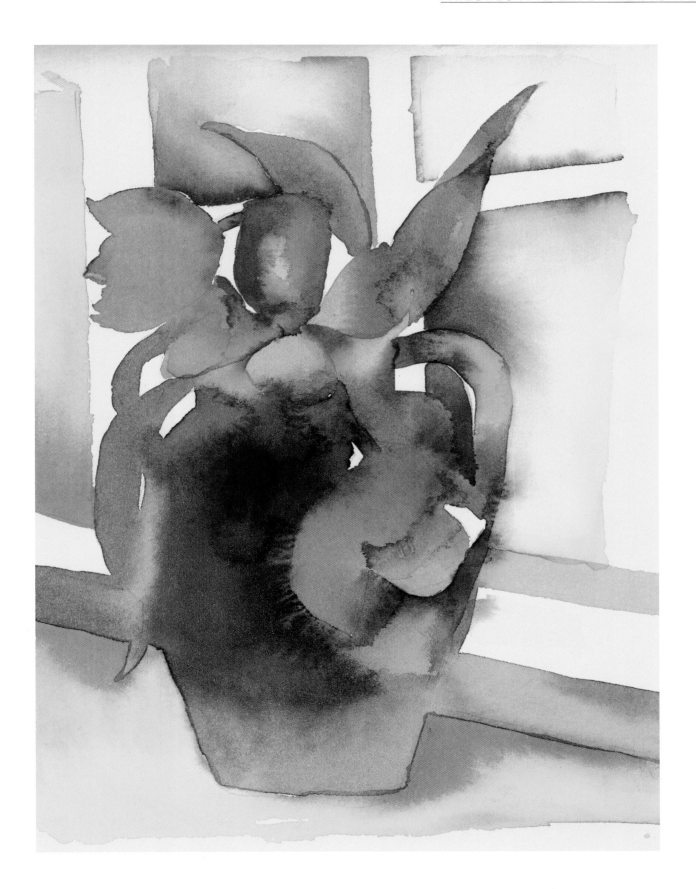

Framing and mounting

This is of paramount importance to *your* work; however, I suffer from DIY phobia and would never tackle mount cutting and framing unless my life depended on it. My philosophy is to leave it to the experts: first, they do a top-class job, and second, I'd hate to do it myself – and I haven't got the time anyway. But if you're very patient and meticulous, then you can do framing and mounting yourself, in which case it is worth investing in a good-quality mount cutter.

You should always use acid-free museum board for mounts, I usually use white, off-white or a shade of cream. Sometimes I use double mounts, but more often than not they are single. Using acid-free mount board guards against mounts becoming discoloured around the cut of the aperture – this can happen within a year if you use non-acid-free board, and the picture will eventually become discoloured. If you've gone to the trouble to use acid-free mount board, also use a piece of acid-free backing paper behind your picture to protect it from the non-acid-free backing board. You can also use acid-free tape to fix the painting to the mount, as masking tape will eventually spoil the picture.

The frame colour depends entirely on the colour and style of the painting. For a detailed piece painted on vellum, usually the frame is a subtle gold or silver – but these colours should not be too brash and glitzy. More modern pieces are often in a more contemporary frame. On a visit to a framer you can try different mount board and

frames by holding samples at the edge of your picture. This is very useful, as immediately you can see if the frame looks too heavy or is the wrong colour to set off your painting. You can now get backing board that is moisture-retardant, thus stopping any damp getting into the back of the picture. Special glass that protects against ultraviolet rays is also available.

If you're likely to exhibit your work, always use D rings for hanging paintings – most galleries prefer them, and other types of fixings can damage frames when paintings are stacked ready to hang in a show.

So many times I've seen work let down by poor mounts and frames. What I find most worrying about this is that it indicates that the artist doesn't value their work enough to set it off well.

BENEFITS OF GOOD MOUNTS AND FRAMES

- They show you value your work.
- They make your work look more expensive.
- They help you exhibit and sell your work.
- Hopefully they will inspire others to mount and frame well.

PROBLEMS WITH FRAMING

- Skinny or mean mounts.
- Cutting into corners of the mount aperture.
- Uneven mounts.
- Grubby mounts.
- Inappropriately coloured mounts.
- Cheap frames that don't meet at the corners.
- Inappropriate frame for the picture.
- Frames that are too narrow to hold the picture in.
- Frames that overpower the picture.
- Dirty glass, inside or outside.
- Wrong colour of frame.
- Damaged frame.
- Using a frame that happens to be there (unless it suits the picture perfectly!).

Where to see plants

I particularly wanted to include this section here, as inspiring places have been incredibly important in the development of my work – and only while writing this book have I realized just how important. Working as an artist is a solitary occupation that suits part of my personality some of the time, but doesn't suit me at all well in other ways, as I'm a very sociable person who loves nothing better than passing hours in chatting and going out.

All the places in the list below are used not only as inspiration, but also as rewards for working hard on my own. I can bear being disciplined and hemmed in at my studio for fairly long periods if I know I'm allowed out later. This said, I still tend to forget to get out enough, as I have a very strong work ethic that argues whether going out to get inspiration is 'real work'. For an artist this is 'real work', of course, but I haven't quite come to terms with it yet, as my work demon expects me to be tied to my easel or board at all hours of the day.

General places

Garden centres
Good florists
Supermarkets
TV gardening programmes

Gardening shows such as the Malvern Spring Show, the Chelsea Flower Show and the Hampton Court Flower Show
Your own garden
Holidays
In the countryside
Books
Libraries
Parks
Seaside
Gardening or painting courses

Specific places

Gilbert White's House and Garden, Selborne, Hampshire
RHS Wisley, Surrey
RBG Kew Gardens, Surrey
RHS Garden Harlow Carr, Harrogate, Yorkshire
The Lost Gardens of Heligan, Cornwall
The Eden Project, Cornwall
Sir Harold Hillier Gardens, Romsey, Hampshire
University of Oxford Botanic Garden
Cambridge University Botanic Garden
Derek Jarman's Garden, Dungeness, Kent
The Beth Chatto Garden, Colchester, Essex
Other RHS Gardens, such as Wakehurst Place, Sussex
Gardens in the National Gardens Scheme

Bibliography

I have always been an avid book collector, not for the sake of collecting, but to read, peruse and enjoy all the subjects that interest me. At first I envisaged just listing many book titles to recommend, but having catalogued them, I realized how often I refer to certain books, while others can sit on the shelf for years until I suddenly need to look at something.

I've owned most of the books listed for a long time, and have never regretted buying any of them or receiving them as a gift. There are hundreds of other art books, too many to mention here, so I've picked out the ones most pertinent to my painting.

The 'Garden' books, such as Tim Smit's *Lost Gardens of Heligan*, are so inspiring. Somehow his enduring enthusiasm and tenacity help me to feel that anything is possible. Reading a book like this reminds me that it's OK to be determined and follow what I believe in – and that's half the battle with doing art.

Some of the other books, such as Rory McEwen's *The Botanical Paintings* and *Contemporary Botanical Artists* from the Shirley Sherwood Collection, are full of the finest examples of botanical art. Although the styles of painting in both of these books are not at all how I paint myself, the compositions, colours, subjects and fantastic quality of the works are so inspiring.

Botanical and flower painting

Contemporary Botanical Artists, The Shirley Sherwood Collection (Weidenfeld & Nicolson, 1996)

Some Flowers, Vita Sackville-West (Pavilion, 1993)

The Flowering of Kew, Richard Mabey (Century Hutchinson, 1988)

In Search of Flowers of the Amazon Forests, Margaret Mee (Nonesuch Expeditions, 1988)

Treasures of The Royal Horticultural Society (Herbert Press, 1994)

The Australian Natural History Drawings, Ferdinand Bauer (British Museum of Natural History, 1989)

The Flora Graeca Story, H. Walter Lack (Bodleian Library, 1999)

The Art of Botanical Illustration, Wilfred Blunt and William Stearn (Antique Collectors Club, 1995)

Monet's Years at Giverny: Beyond Impressionism (Metropolitan Museum of Art, 1978)

The Tulip, Anna Pavord (Bloomsbury, 1999)

Fruit: An Illustrated History, Peter Blackburne-Maze (Scriptum, 2002)

Flora: An Illustrated History of the Garden Flower, Brent Eliott (Scriptum, 2001)

The Botanical Paintings, Rory McEwen (Royal Botanic Gardens, Edinburgh, 1988)

Art instruction

Drawing on the Right Side of the Brain, Betty Edwards (HarperCollins, 1993)

Drawing on the Artist Within, Betty Edwards (Collins, 1987)

The Colour Mixing Bible, Ian Sidaway (David & Charles, 2002)

The Artist's Handbook, Ray Smith (Dorling Kindersley, 2003)

Gardens and plants

The Lost Gardens of Heligan, Tim Smit (Victor Gollancz, 1999)

The Eden Project, Tim Smit (Corgi, 2002)

Flora Britannica, Richard Mabey (Chatto & Windus, 1997)

The RHS Encyclopedia of Garden Plants and Flowers (Dorling Kindersley, 1996)

Beth Chatto's Garden Notebook (Orion, 1998)

The Private Life of Plants, David Attenborough (BBC Publications, 1995)

The Natural History of Selborne, Gilbert White (Penguin Classics, 1977)

Gilbert White, Richard Mabey (Pimlico, 1986)

Watercolour paintings

British Watercolours at the Victoria & Albert Museum, Ronald Parkinson (V&A Enterprises, 2002)

Other

The Gallery Companion, Marcus Lodwick (Thames & Hudson, 2002)

Index

abstraction 114–15
Aechmea 27
Alstroemeria 88, 104–13
anemone 116–17
anthurium 42–3
autumn colours 30–1, 64, 98–9, 118

backgrounds
green leaves 82–5; white 46–7; white flowers 77
banana plant 23
boards 14, 17
Bonnard, Pierre 6, 7
broken effects 14
brushes 15, 17; care of 15; size 7, 11, 15, 59, 66, 88
bulbs 21, 92–5, 115

cardoon 65, 119
charcoal 13
clematis 78–81
colour 7, 22–39; basic palette 24, 25, 32; complementary 34; cool and warm 34–7; exploration 104–13; limited palette 23; mixing 32–3, 57; reflected 75, 77; and space 34; and tone 38
composition 7, 17, 42–9, 86; format 46; measuring and marking 46, 48, 52; size 46, 50
cool colours 34, 35–7
cropping 17
cutting equipment 12, 14
cyclamen 52–3

dappled effects 14
detailed work 7, 12, 21, 86–99
Dracunculus vulgaris 67
drawing 64; equipment 12–13; measuring and marking 46, 48; outline (contour) 44, 48; sketching 13, 45; underdrawings 12; working without 114

Ehret 18
enlarging 78
eraser 12, 44
experimentation 114, 122

flower care 56
folds and creases 83
format, choosing 46, 48
framing 124
Frankenhaler, Helen 7
free flowers, painting 25, 122, 123
Frost, Terry 7
fuchsia 50–1, 103

ginger plant 46–7
glazes 69
greens 26–9, 34, 36, 64
guzmania 120–1

Hedysarum 89
Helleborus 68–73; *H. foetidus* 18, 29; *H. orientalis* 33
Heron, Patrick 7
Hockney, David 7
Hodgkin, Howard 7
honeysuckle 96
hosta 118
Hot-Pressed (HP) paper 14

impressions, creating 64, 66–7, 102, 114
ink 13
Iris 8–9, 56, 88, 104–13; *I. foetidissima* 97

John, Gwen 7

Klee, Paul 7

layout paper 12, 44, 58, 92–3
leaves 62, 64, 65, 69–71, 84, 109; autumn 30–1, 99, 118; as background 82–5; colour palette 26–9; impressionistic 64, 66;

large 11, 64; outline drawing 44
light and shade *see* tone
lighting 17, 56–7, 66
lily 54–5, 62–3, 88; arum 36–7; calla 38–9, 100–1; martagon 96
looking, importance of 44, 45, 48

McEwen, Rory 7
magnifying glass 12, 21, 64
magnolia 73–4, 76, 77
masking fluid 17
masking tape 17
measuring and marking 46, 48, 52
mounts 124
movement 34

negative shapes 48, 49, 50, 83, 84, 106
Nicholson, Winifred 7
NOT (Cold-Pressed) paper 14
notebooks 17

outside, working 20–1, 30

paint boxes 16; ready-filled 24
painting courses 21
paints 16, 24
palettes 16, 17
pansy 57–61, 88
paper 14
parchment 18
pastel 13
pen and ink 13
pencils 12, 13
photographs, working from 78
pinks, mixing 24
pipettes 17
poppy 34, 118
pouncing vellum 91
protea 48–9

reds 24, 33
rose 98
Rough paper 14

seed heads 96–8
shadows 72–3, 88, 94; white flowers 75, 77, 82; *see also* tone
simplification 49, 64, 66, 88
sketchbooks 12, 13, 17, 45
sketching 13, 45; and composition 5, 43
space 34, 38
sponges 17
spontaneity 7
stamens 51, 81, 83, 88
stems 45, 50, 61, 62, 66, 67, 71–2; colours for 26–9
structure 62, 64, 66
stippling 67
strelitzia 38, 40–1, 64
sweet pea 24

texture 14
tone 38–41, 44, 60, 72, 73
tracing paper 12, 44, 58, 92–3
tulip 6, 10–11, 25, 34, 64, 86–7, 104–13
tulip tree 98–9

underdrawings 12

veins 59, 64
vellum 7, 12, 18–19, 21, 90–9
preparation 90–1

warm colours 34
wet-onto-dry technique 84
wet-onto-wet technique 14, 33, 58, 84, 90, 119
white; backgrounds 46–7; flowers 73–85, 98
working space 20–1

yellows 25, 77, 112

Acknowledgements

I would like to thank Chris Horridge for his unwavering support while I've been working on this book.

All the staff at Gilbert White's House have helped me in numerous ways over the last five years; I would particularly like to thank Anna Jackson for her support and great enthusiasm for my work at the House.

I would like to thank Peter Kettle for some of the information about framing.

Thank you to Ian Kearey for all his hard work transcribing the text, helpful advice and encouragement, and his refreshing sense of humour; and also to George Taylor for his superb photography and patience faced with so many 'white backgrounds'.

Finally, I would like to thank Sue Cleave and Freya Dangerfield for all their support and encouragement, and again Freya for believing in the idea for this book in the first place.